GVS.TAV KLIMT one hundred drawings

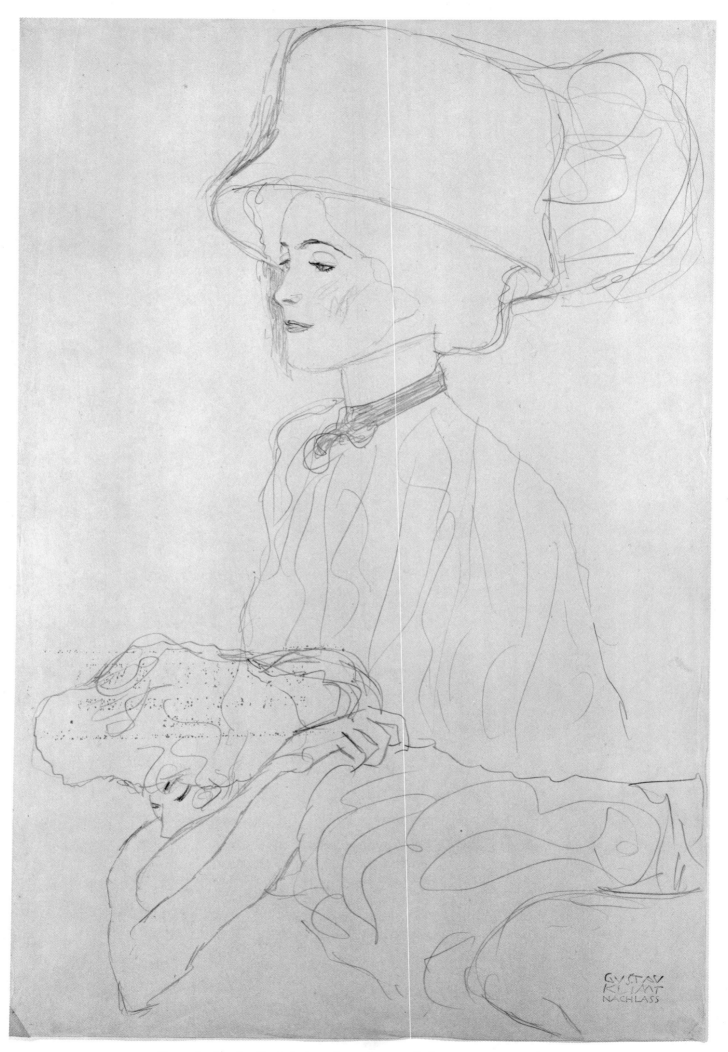

Portrait sketch of a lady in a large hat; reclining woman; 1905/12.

GVSTAV KLIMT one hundred drawings

with an introduction by Alfred Werner

DOVER PUBLICATIONS, INC., NEW YORK

Published in Canada by General Publishing Company, Ltd., 30 Lesmill Road, Don Mills, Toronto, Ontario.
Published in the United Kingdom by Constable and Company, Ltd., 10 Orange Street, London WC 2.

Gustav Klimt: 100 Drawings is a new work, first published by Dover Publications, Inc., in 1972. The publisher is grateful to Mr. Serge Sabarsky, who loaned 53 original drawings for reproduction and furnished much documentation. The other 47 drawings in this volume are reproduced from two portfolios of facsimiles: (1) *Gustav Klimt: fünfundzwanzig Handzeichnungen*, published by Gilhofer & Ranschburg, Vienna, 1919; and (2) *Gustav Klimt: 25 Zeichnungen ausgewählt und bearbeitet von Alice Strobl*, published by the Akademische Druck- und Verlagsanstalt, Graz (Austria), 1964 (used by special arrangement with the original publisher).

International Standard Book Number: 0-486-22446-5
Library of Congress Catalog Card Number: 78-157434

Manufactured in the United States of America
Dover Publications, Inc.
180 Varick Street
New York, N. Y. 10014

Introduction

There was a time when Klimt's name was a battle-cry for those progressive Austrian artists who were fed up with the pseudo-classical, pseudo-Baroque spirit that continued to dominate Vienna. In 1897 he led an exodus of the young from the arch-conservative Künstlerhaus, whose middle-aged members were still painting historical anecdotes and mythological themes in an antiquated manner. These seventeen rebels formed a new association, with an exhibition hall of their own and a large, superbly illustrated magazine, *Ver Sacrum*. This group was later known as *Secession*, and the manner in which its members expressed themselves, as *Secessionsstil*. Its foremost representative, Gustav Klimt (1862–1918), became famous, or rather notorious, in his native city largely on account of a "scandal" revolving around three large oils he painted for the entrance hall (Aula) of Vienna's University: they were rejected as "immoral" and even "pathological." By and large, however, he received more attention abroad than in Austria. He was the only Austrian to be made an honorary member of the International Society of Artists, presided over by Whistler, with headquarters in London. Paris awarded him a Grand Prix, Rome a Medaglia d'Oro. It was only in 1917 that honorary membership in the Vienna Academy of Fine Arts was bestowed upon him. A few months later, on February 6, 1918, he died of a cerebral hemorrhage.

There was an eclipse of several decades. He was never forgotten in Central Europe, but outside he was insufficiently known and appreciated until the 1960's, when comprehensive shows in Italy, France, England and the United States belatedly called attention to this sensitive and subtle "*fin-de-siècle* decorator." His current vogue may, in part, be traced to the revived interest in Art

"Truth is a fire, and to speak truth means to shine and to burn."
—KLIMT, ON A SKETCH FOR THE PAINTING NUDA VERITAS

Nouveau, whose Austrian manifestation, *Secessionsstil*, he so well exemplified. It may also be due to the more recent fascination with what has been dubbed "Erotic Art." Klimt, after all, was preoccupied with one theme: the female, mysterious and even frightening, yet a perpetual source of exquisite delight.

While handbooks on art no longer omit his name, not enough is said about his superb draughtsmanship. Indeed, some might prefer his drawings, with their direct and immediate appeal, to his elaborate and complex compositions in oil that appear encumbered by too much symbolism. Nevertheless, Klimt's paintings illustrate remarkably well Austria's *belle époque*, the closing decades of the Hapsburg Empire, when the glittering façade barely concealed the rot at the very foundations of society. His portraits of Austrian bankers' wives make these pampered darlings look like exotic birds, bedazzled by their own plumage; all the gold and silver sequins and precious, enamel-like pigments cannot hide the sitter's uselessness, nor the underlying gentle melancholia. In Klimt's quasi-pointillist renderings of gardens, parks, orchards and towns along lakes, there is no air that we can breathe; the greens and blues are not to be found in nature. Significantly, the human figure is absent from these sad landscapes that are spread out like ornamental rugs.

In these pictures, and in those that deal melodramatically with more philosophical themes, Klimt's mannerism, with mosaic-like patterns and hieratic poses, sets him apart from the conservative "establishment" of his time. But it also indicates the gap that was to separate him from a younger group of rebels, among them his own disciple, Egon Schiele, and Oskar Kokoschka, foremost representatives of what became known as "Viennese Expressionism."

In his drawings, however, Klimt created a bridge between the classical style of the last century and the prophetic explosiveness that welled up just prior to World War I. "He emerges at his best as a draughtsman," Gustav Glück, for many years director of Vienna's Kunsthistorisches Museum, wrote as early as 1922; Glück considered the drawings "perhaps the ultimate of Klimt's artistic achievement." More recently, Fritz Novotny, long a director of the Österreichische Galerie, which owns some of the most important oils of Klimt, hailed him as "one of the great draughtsmen of the period," and pointed to the "spiritualization" achieved by the master's graphic manner. His drawings, indeed, do not reflect the severe Art Nouveau stylization of his canvases. Ranging from the somewhat pedantic, uncertain exercises of the young

student to works completed just before he died, they reveal a progress, an advance to greater and ever greater freedom, lightness, spontaneity.

His paintings, upon which he worked very slowly and fastidiously, do not number much above two hundred; his drawings have been estimated in the thousands. Friends recall having seen his atelier virtually "littered" with them. A good many, while unmistakably revealing the master's hand, are ephemeral, but quite a few are full-fledged and fully realized. To him, his drawings were more than preparatory sketches, although he signed his name only to the few that he dedicated to friends or sold, and rarely dated the drawings he produced in his years of maturity. (He signed his drawings in block letters, his first name above his surname; the unsigned drawings carry the stamp of the estate, "Gustav Klimt Nachlass," or a note in the hand of the artist's sister, Hermine; some, from the collection of Klimt's sister Johanna Zimpel and her son Rudolf, bear on the reverse the stamp "Johanna Zimpel" or "Nachlass Gustav Klimt Sammlung R. Zimpel.") Unlike Gauguin, who refused to show his drawings ("They are my private letters, my secrets"), Klimt readily included his in his one-man exhibitions. Several were reproduced in *Ver Sacrum*. One number of that magazine was even confiscated by the Austrian authorities on account of the "obscene" drawings related to *Medicine*, one of the above-mentioned rejected pictures, originally destined to adorn the University. But this was in the Vienna of 1900, whose populace was outraged by girls riding bicycles, and ballerinas dancing without stockings! It was the hypocritical city where even in art the open display of the body was frowned upon unless demanded by allegorical themes. Stefan Zweig later described the "sticky, sultry, unhealthy atmosphere" that prevailed in Imperial Vienna, with its "dishonest and unpsychological morality of secrecy and hiding." Klimt wounded public sentiment by not considering any part of the human anatomy ugly, shameful or ignoble, and was made to suffer repeatedly for not playing the national game of falsehood.

He was not really hounded, however, as were his two younger successors. Kokoschka temporarily fled abroad to escape the threat of prosecution. Schiele at one point was arrested on account of certain renderings of nude girls; at his trial the judge set fire to one of these drawings. But how "tame" in their erotic appeal even the frankest works of all three are compared to some of the offerings of the 1960's and 1970's!

In his drawings, Klimt often used charcoal, black chalk, colored crayons, or a mixture of two or three media, and occasionally pen and ink. But his favorite was the graphite pencil (which was also preferred by Gainsborough and Romney, Ingres and Delacroix, and by Degas, Cézanne and Modigliani). At first a kind of tan wrapping paper served his purposes, but later he employed almost exclusively the soft and delicate whitish Japan paper. His drawings were frequently reproduced in albums (one edition had a foreword written by the distinguished Austrian playwright and essayist, Hermann Bahr). Unfortunately, their desirability—they were snapped up by collectors and fetched high prices—led to some forgeries; facsimiles were often sold as originals. Many of the small sketchbooks the artist carried in his pockets are no longer in existence. They were lost, along with several major paintings by Klimt with which they were stored during World War II in a castle in Lower Austria, when a member of the retreating Nazi army put a torch to the building.

Klimt developed slowly. As a student at the Kunstgewerbeschule des österreichischen Museums für Kunst und Industrie, he made numerous careful anatomical studies of male as well as female models. Were they not by his hand, these sketches—fastidious and delicate—would not have been preserved. After he had set himself up, with his brother and a colleague, as a decorator of building interiors, his virtuosity was expressed largely in drawings that served in the execution of these commissioned paintings rather than as independent graphic works. Klimt matured as an artist when he was about thirty-seven; it was then that he became the Klimt the world has now admired for many decades.

Vienna's professors had not succeeded in restraining or perverting his inherent genius. These teachers were, of course, still bound by a pedagogical theory that demanded from the neophyte that he must draw, draw and draw again, first from plaster casts of antique sculpture and then from live models, for years before being permitted to pick up a brush. The prevailing doctrine was that drawing contained everything except the hue (which would be added as an afterthought). All of this would not have been detrimental, had not the teachers contented themselves with instilling no more than a superficial accuracy, based on a good knowledge of anatomical facts. Their pupils were dismissed after they had become efficient copyists whose drawings reveal no personal, spontaneous reaction to the subject or, for that matter, to the world.

It took Klimt many years to grasp how absurd this desired and required "realism" was. After all, nature presents us with colored and inflected surfaces to which only polychrome sculpture might correspond—nowhere does it present lines. Drawing, the least ponderous, the most perishable and also most transitory of all media, has, if well understood, the advantage of being the artist's most subjective, most spiritual activity: the strokes, far from having a direct relationship with experience, can have only a symbolic one. Once an artist has become aware of this, he can freely disregard most of the rules he has taken such pains to master.

This is what Klimt did by training himself, gradually, to think in linear terms, to eliminate all unnecessary detail, from white "highlighting" to shadows and traditional perspective as means of simulating convex and concave three-dimensionality. Only as a mature artist did Klimt fully realize that he must transcribe just what interested him, and that he must never avoid any abbreviation, elision or exaggeration that served aesthetic purposes. He reached his peak as a draughtsman after he had understood that a poetic hint can tell more than a laboriously narrated piece of prose. Hence, his final drawings have "the lightness of a net of gauze," as one reviewer put it. If his paintings are often tight and overly dense, as a draughtsman he allowed his creative energy to flow unchecked from the rapidly moving pencil.

To accomplish what he did he had to be thoroughly, completely familiar with his motifs. Actually, there was only one motif: the magic thrill a man experiences on seeing a female in the nude. What has been said of the painter and draughtsman Pascin— that his universe was woman's body—can be as well applied to Klimt. In the drawings he produced in his two final decades—and these are the ones that count—women rule; males appear, but only as adjuncts to women. Surprisingly, there are no sketches for landscapes, although from about 1898 onward he frequently painted rural scenes, largely inspired by what he saw on vacationing in the Salzkammergut region.

Klimt's indisputable eroticism was healthy and simple, unlike that of his admirer, the oversophisticated and often cynical Pascin. Klimt had no trace of the lewdness of a Bouguereau, the misogyny of a Degas or Munch, the detachment of a Toulouse-Lautrec. "Unmoved by the temptations of a frivolous society," as a friend aptly characterized him, Klimt lived mainly for the pursuit of art, looking at woman with interest rather than passion. In a metropolis where the main topics of conversation were the love

affairs of celebrities, the art-obsessed Klimt provided no grounds for any scandalous gossip. He had a life-long liaison with a woman who shared his artistic preoccupations, but, yearning for complete independence, he would not marry her, lest such a union alter his way of life and impede his flow of masterworks.

It was known, though, that he was generally surrounded by nude models while working in his atelier—a whim he shared with Rodin. Actually, this was method rather than whim: the girls moved around at ease, lost the awareness of his presence and allowed the master to catch unself-conscious body attitudes. Thus he could contemplate them somewhat the way an *animalier* would study the forms and attitudes of dumb creatures. He sketched them singly, or in groups of two or three, standing, sitting, or casually enveloped in the lassitude of sleep. While other artists often place the nude in a setting of flowers or furniture, Klimt's ladies are shown without any distracting accessories (cushions, chairs, lounges are only hinted at). In the manner of the Expressionists, who were to come in the next generation, Klimt focussed attention on the erogenous zones (as a pure Art Nouveau practitioner would never have done). Her knees spread, the model displayed herself fully to him—and he drew her as she appeared. Boldly, he scorned the classic convention of concealing the pubic hair by a bit of drapery or a hand directed in the socially prescribed gesture of modesty.

A calmness, a serenity prevails in these studies. Yet these drawings are far from static. There are often swirls of ecstasy, arabesques of excitement in the rapid calligraphic line. If the model is clothed, a rhythmical swing is produced by the curvilinear ripple of the folds. While the sitter's character is not the artist's main concern, there is, nonetheless, a subtle and discreet psychological penetration into personality through a shorthand delineation of gesture. At times, only part of the body is sketched; yet the undulating unbroken line has an imperious assuredness that commands the spectator to complete the contour in his mind's eye.

The present volume is the first to present Klimt to art lovers in America as the master draughtsman that he was. These works should earn for Klimt the accolade Bourdelle gave the drawings of Rodin:

"These white pages tremble forever with his spirit's emotion before the wonders of nature."

ALFRED WERNER

List of Illustrations

Dimensions are given in millimeters (100 mm = 3.937 inches), height before width. Sources of the illustrations are designated by one of the following numbers:

1 = Reproduced from originals loaned by Serge Sabarsky, New York.
2 = From the 1919 facsimile portfolio Gustav Klimt: fünfund-zwanzig Handzeichnungen, *Gilhofer & Ranschburg, Vienna.*
3 = From the 1964 facsimile portfolio Gustav Klimt: 25 Zeichnungen *ausgewählt und bearbeitet von Alice Strobl, published by the Akademische Druck- und Verlagsanstalt, Graz.*

Information given here on drawings from sources 2 and 3 is partially based on data in the book Gustav Klimt *by Fritz Novotny and Johannes Dobai (Frederick A. Praeger, N.Y., 1968), which has been taken as the final authority, and on personal communications from Serge Sabarsky. Wherever possible, the names of present (or the latest) owners are given.*

PLATES

Portrait sketch of a lady in a large hat; reclining woman; 1905/12; pencil; 559 × 371. (1) (*Frontispiece*)

1 Male figure study; 1876/80; pencil; 448 × 314. (1)

2 Pair of boots; 1876/82; pencil with white highlights; 450 × 315; Scott Elliott, New York. (1)

3 Reclining nude; c. 1888; black crayon with white highlights; 287 × 425; inscription: "Nachlass meines Bruders Gustav/ Hermine Klimt"; Albertina, Vienna. (3)

4 Study for the floating nude with outstretched left arm in the ceiling panel *Medicine* (1900–07) in the great hall of the University of Vienna; c. 1897; black crayon; 415 × 273; Albertina, Vienna. (3)

5 Study for the drawing "The Witch" in the magazine *Ver Sacrum*, Vol. 1, No. 2, 1898; black crayon; 450 × 313; Erich Lederer, Geneva. (2)

ILLUSTRATIONS

ILLUSTRATIONS

ILLUSTRATIONS

ILLUSTRATIONS

The Drawings

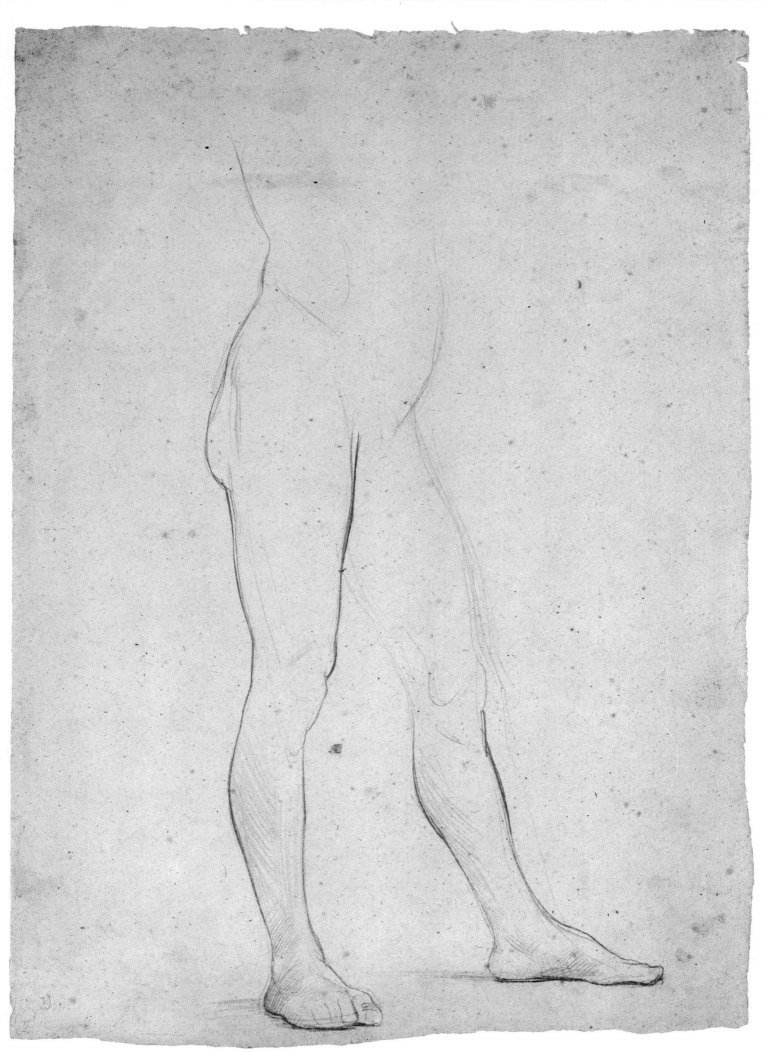

1. Male figure study; 1876/80.

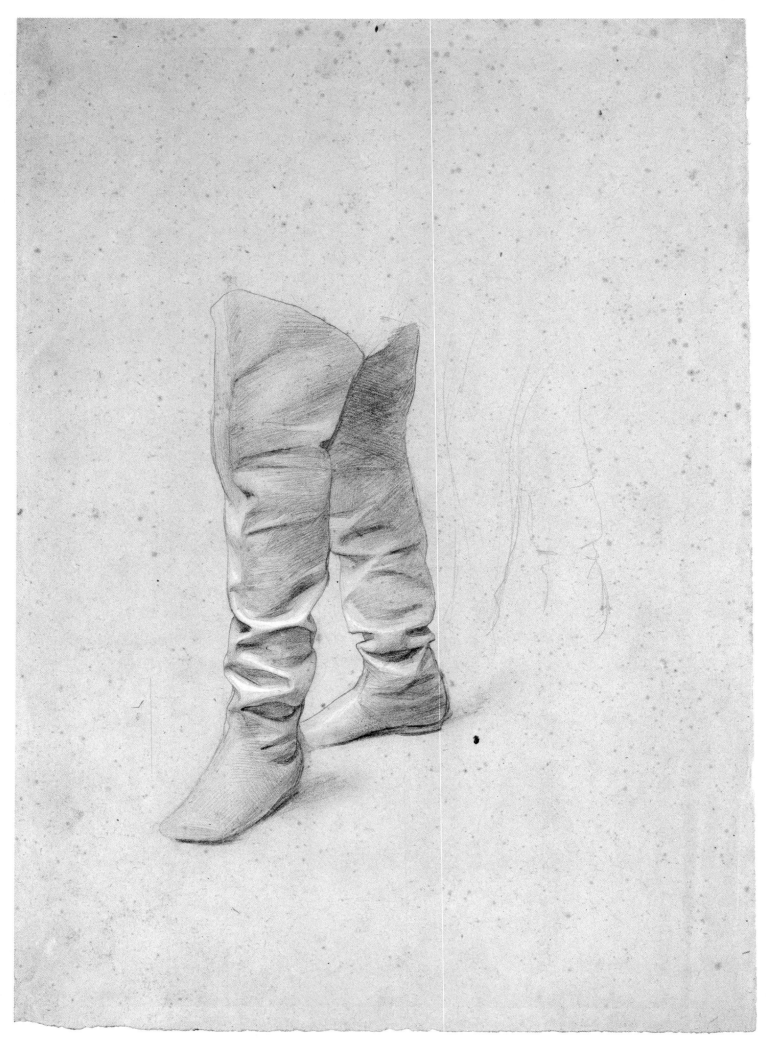

2. Pair of boots; 1876/82.

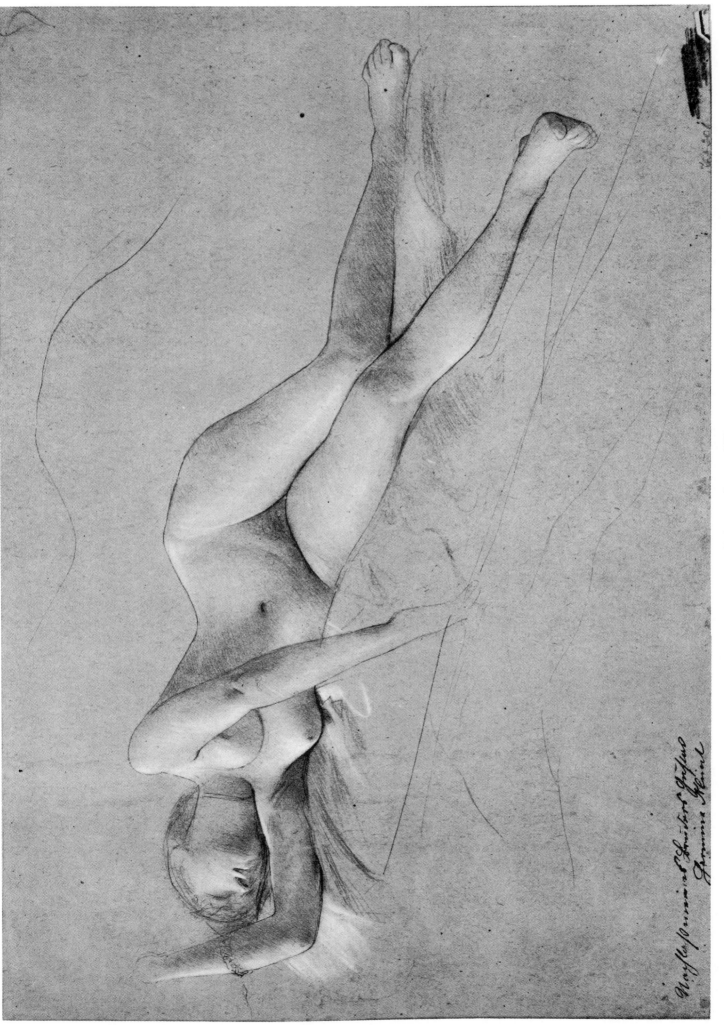

5. Reclining nude; c. 1888.

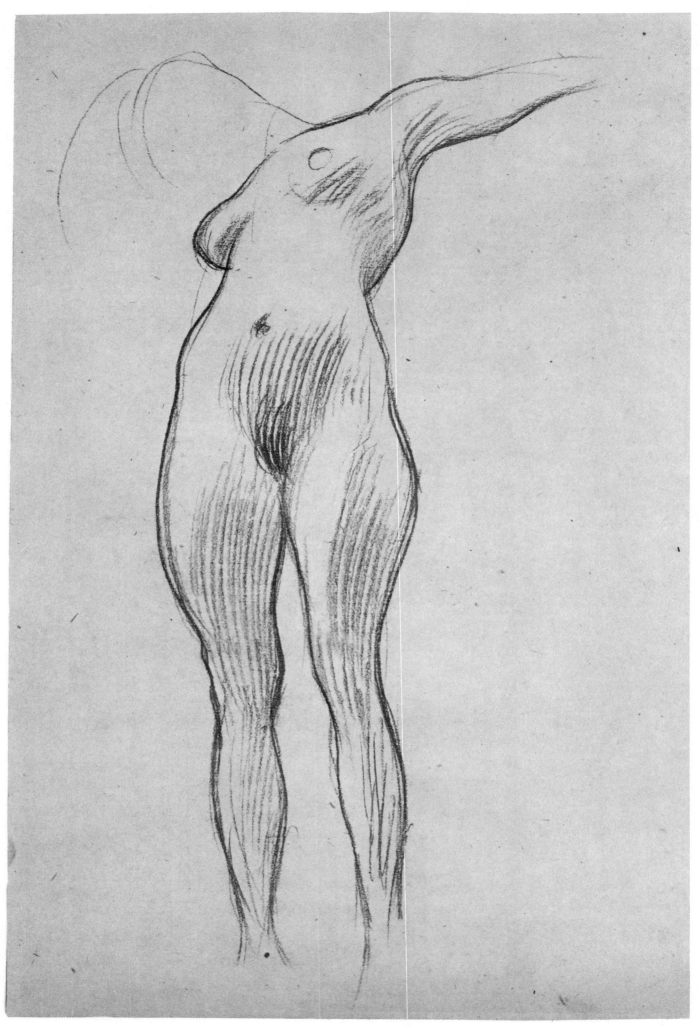

4. Study for the floating nude in *Medicine*; c. 1897.

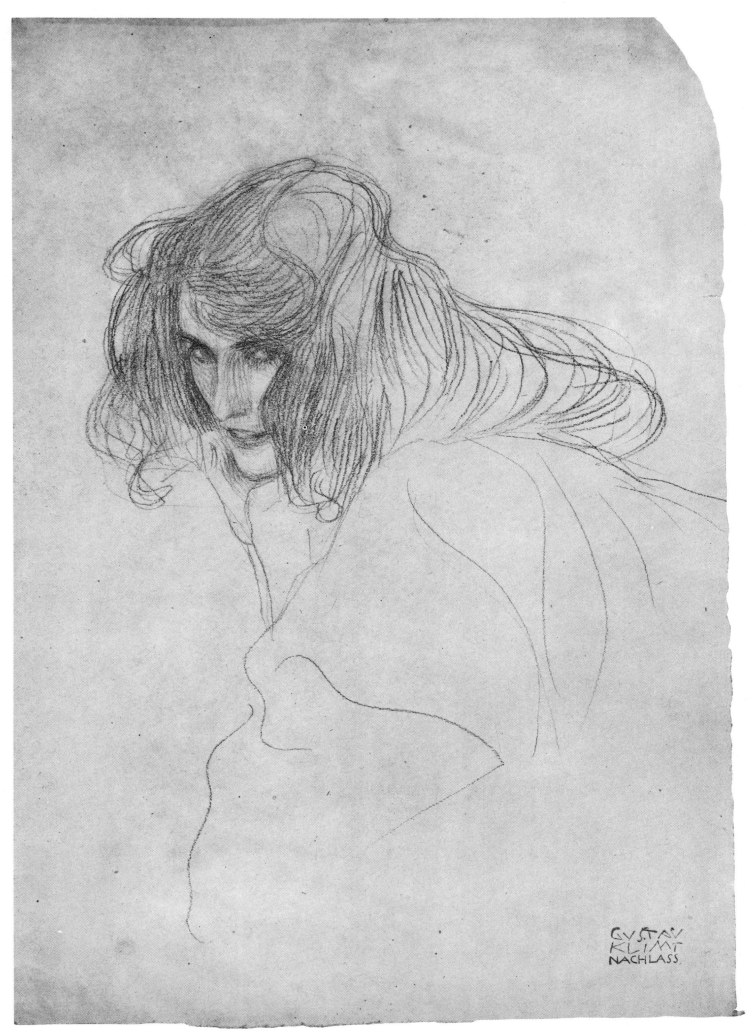

5. Study for the drawing "The Witch"; 1898.

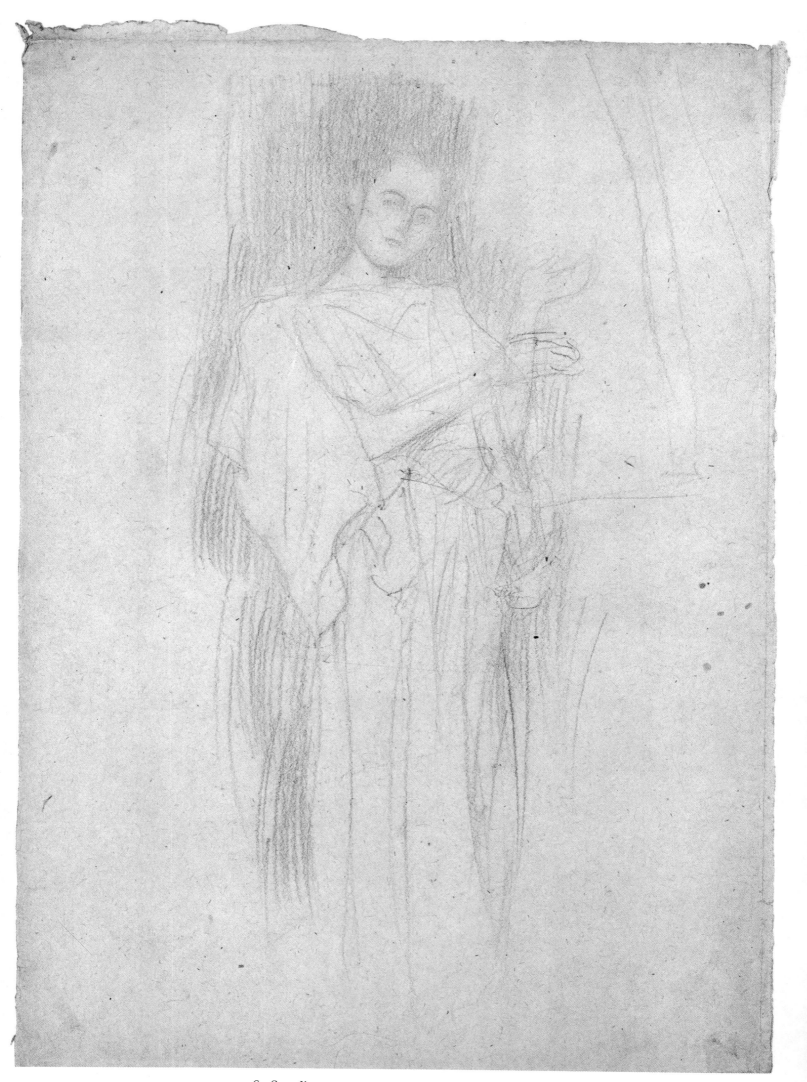

6. Standing woman in classical drapery; c. 1898.

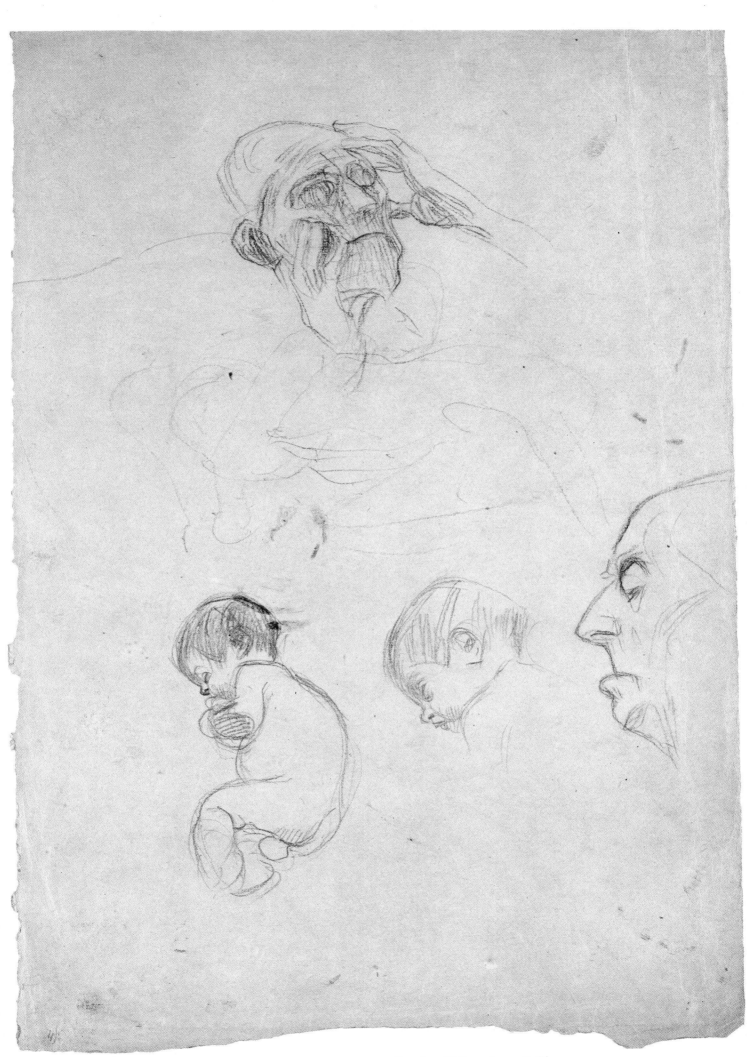

7. Man's head and baby; studies for *Philosophy*; 1898/9.

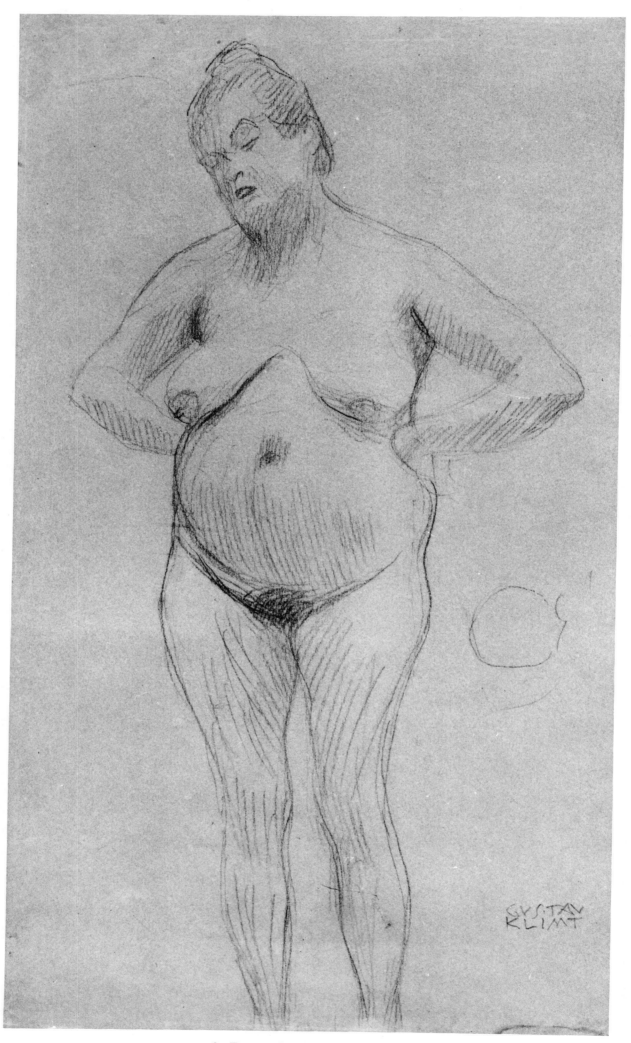

8. Fat standing nude; c. 1900.

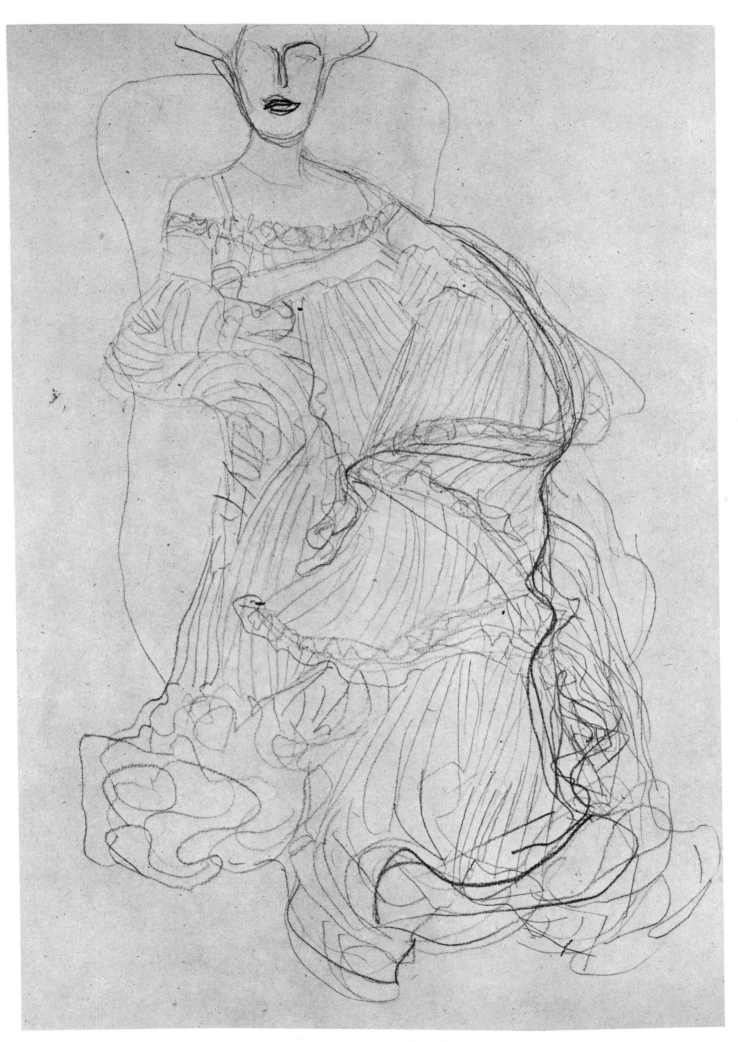

9. Study for the first portrait of Adele Bloch-Bauer; c. 1900.

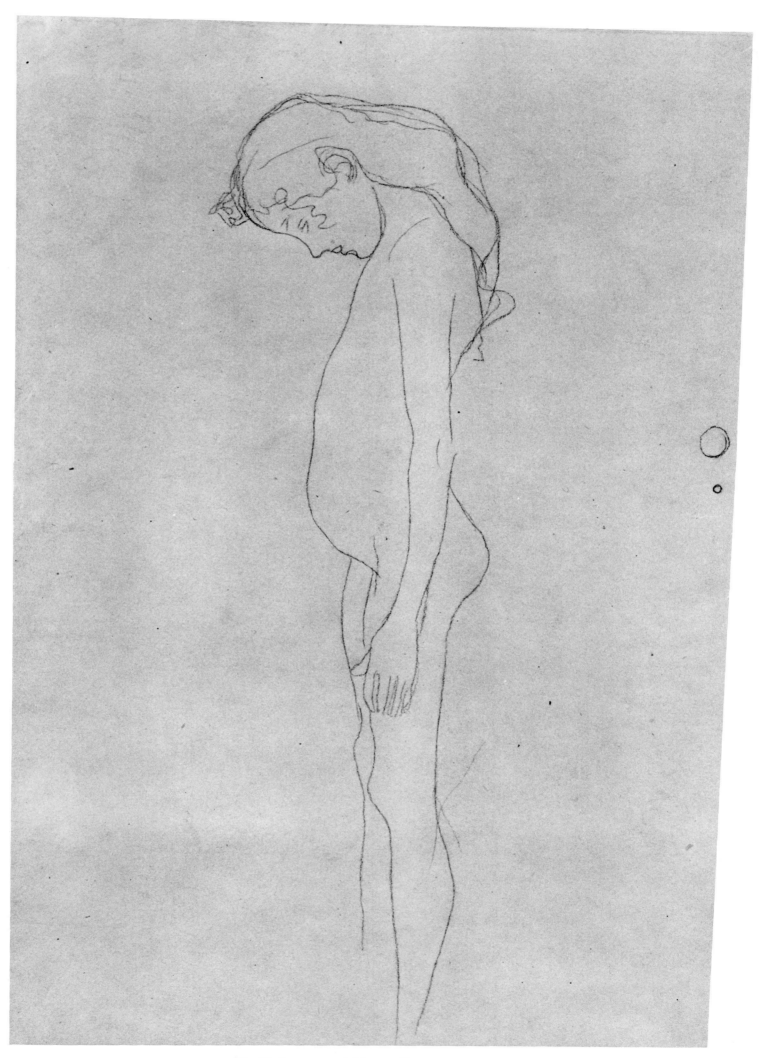

10. Nude young girl in profile; c. 1901.

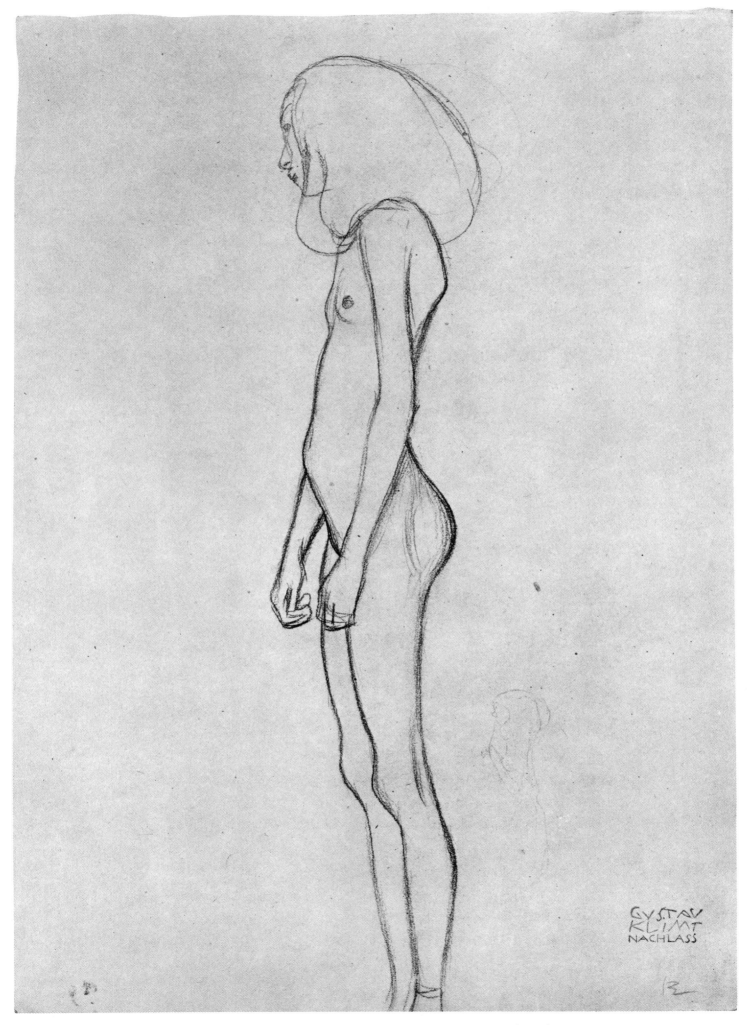

11. Study for the young girl in *Longing for Happiness* (1902).

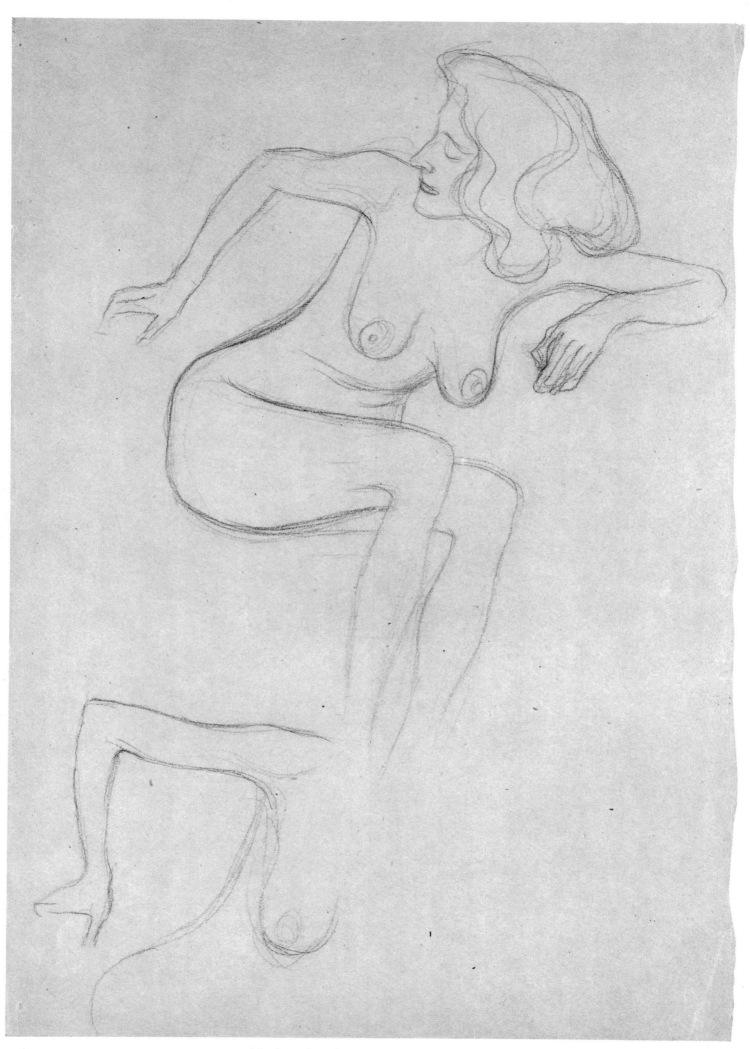

12. Seated nude leaning forward; 1902.

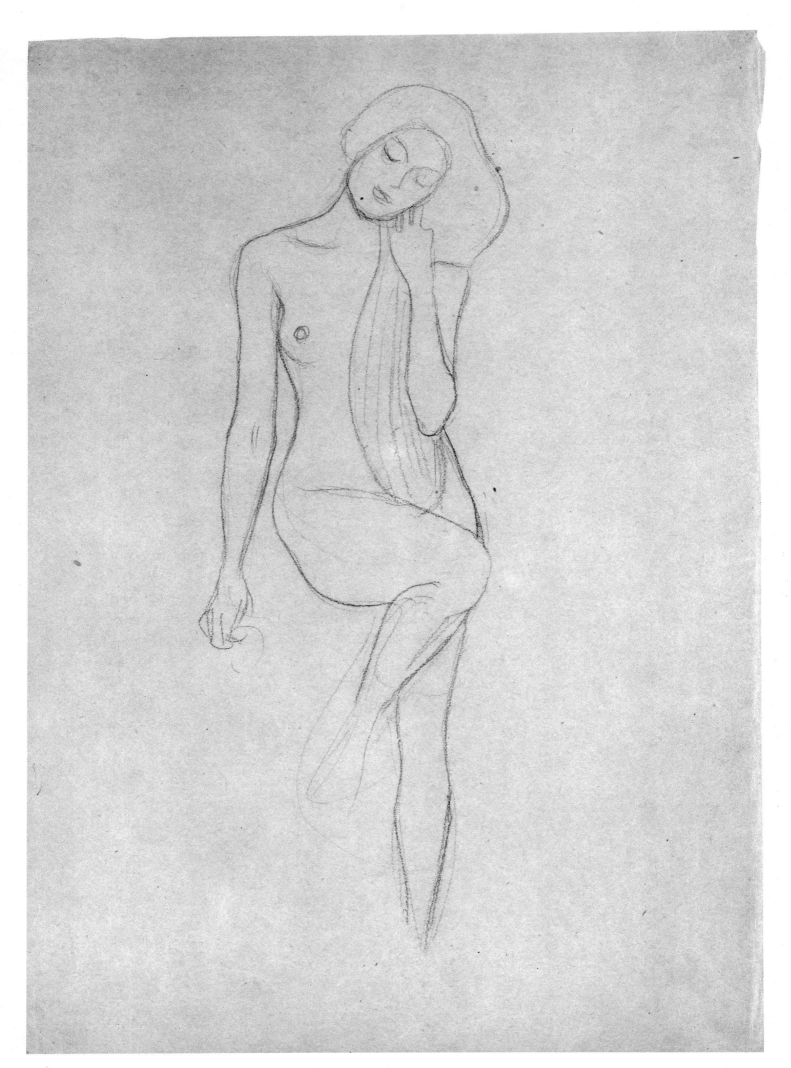

13. Standing nude with long hair; c. 1902.

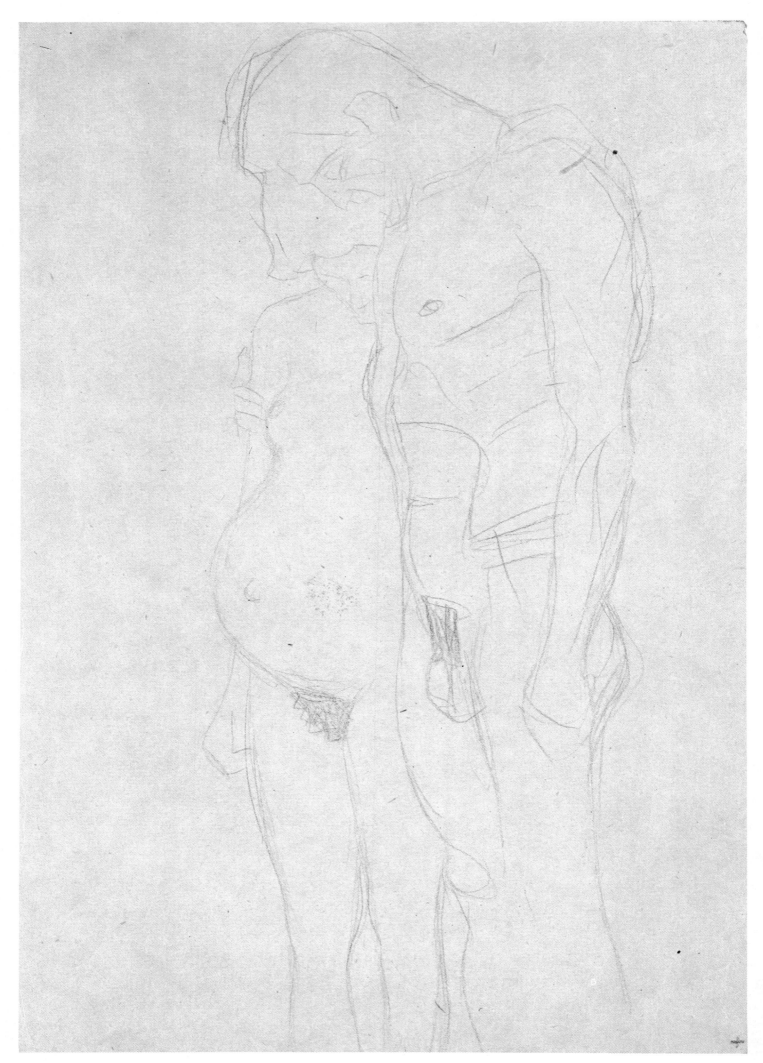

14. Study for *Hope I*; 1902/03.

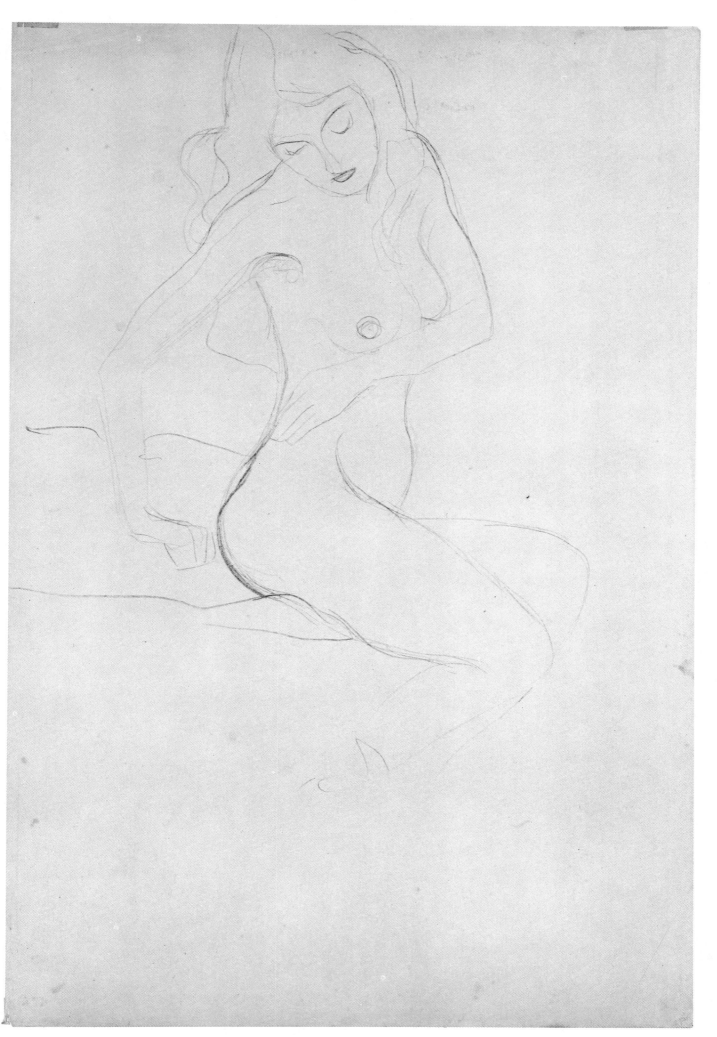

15. Nude with shoulders turned to the left; 1902/05.

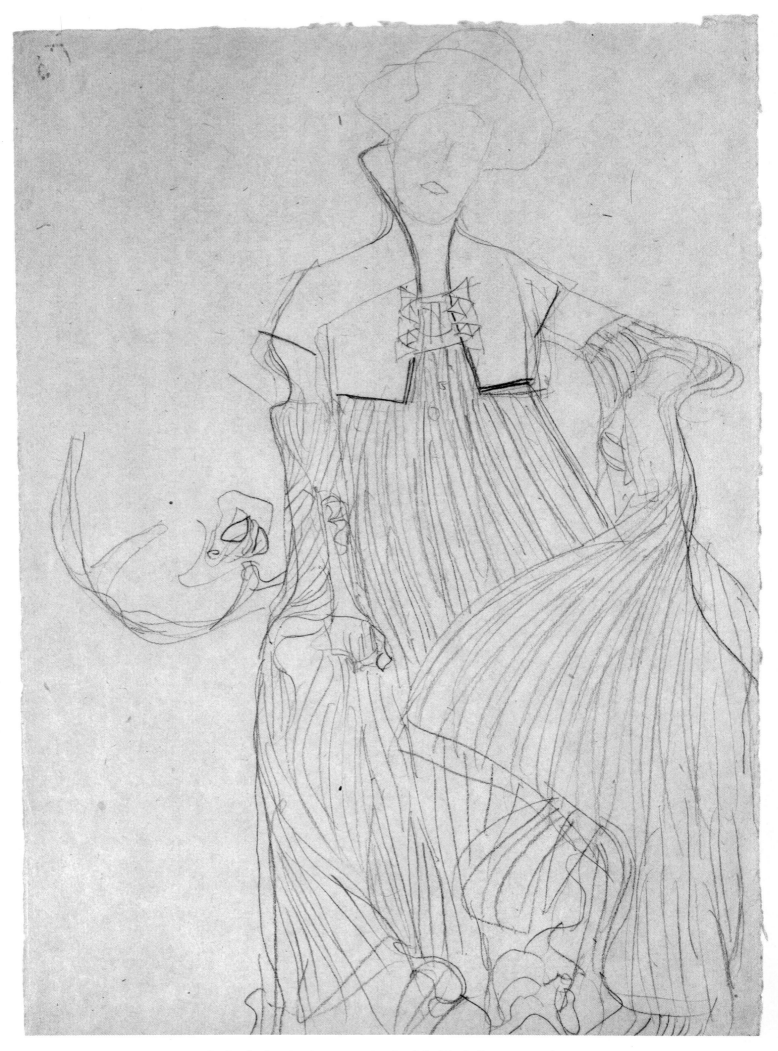

16. Study for the first portrait of Adele Bloch-Bauer; 1902/07.

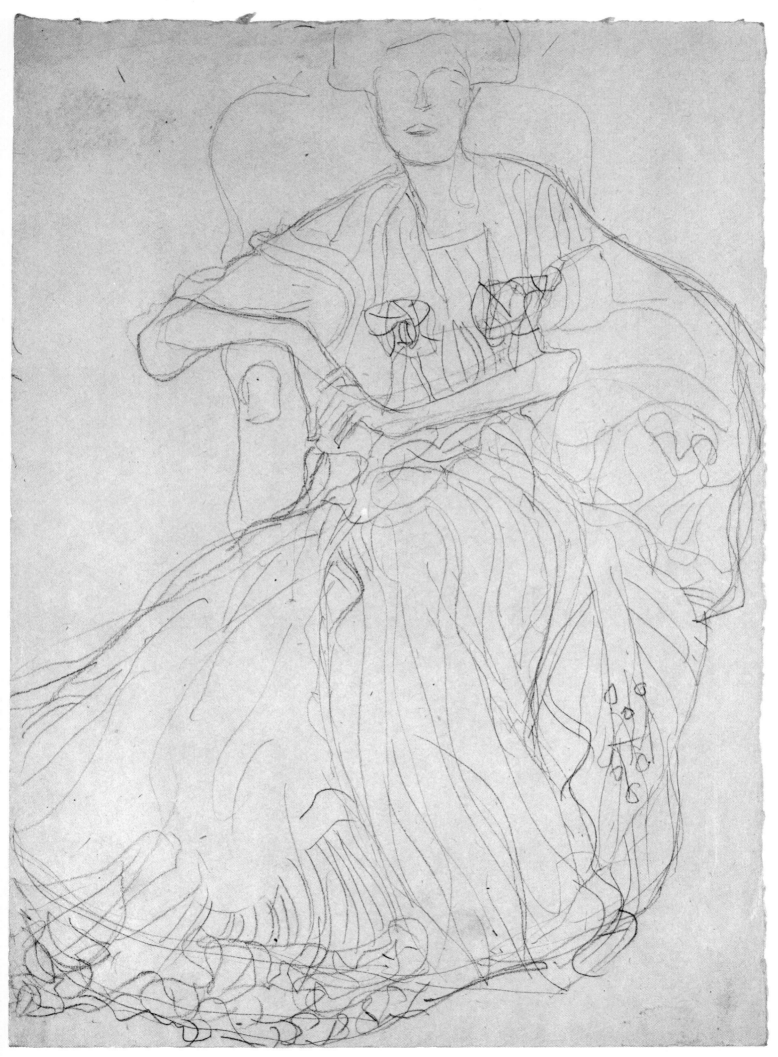

17. Study for the first portrait of Adele Bloch-Bauer; 1902/07.

18. Standing nude with hands lifted to her cheek; 1903.

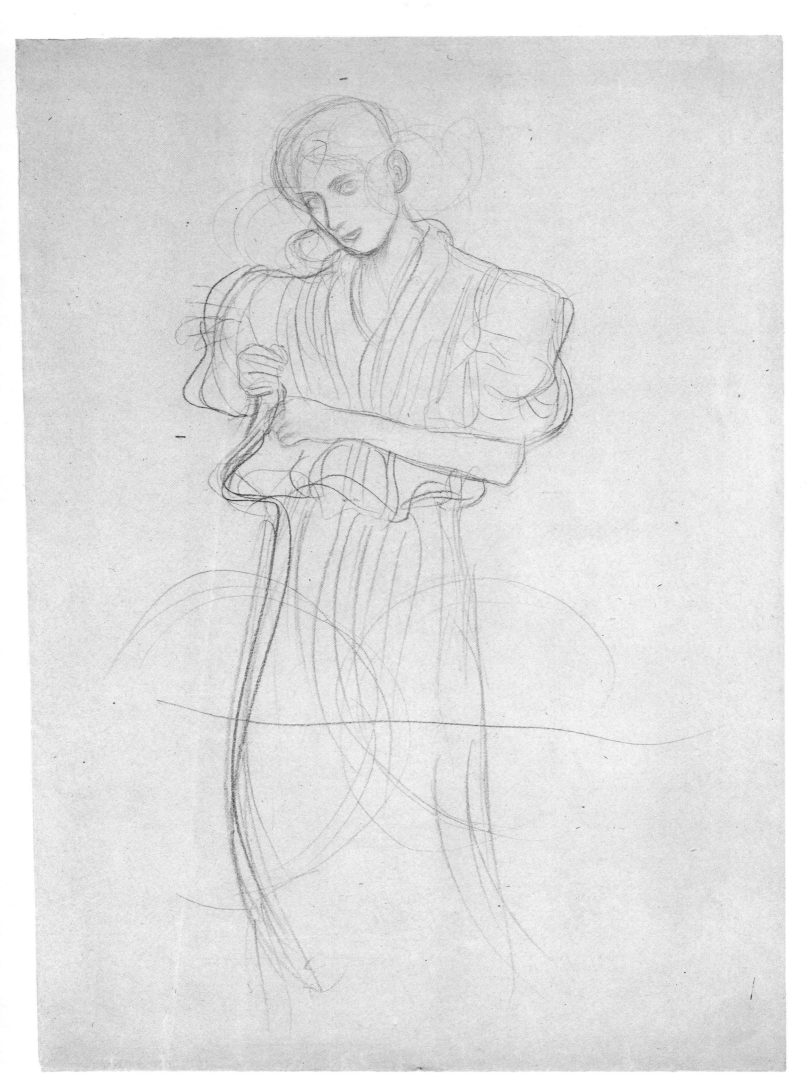

19. Standing robed woman; 1903.

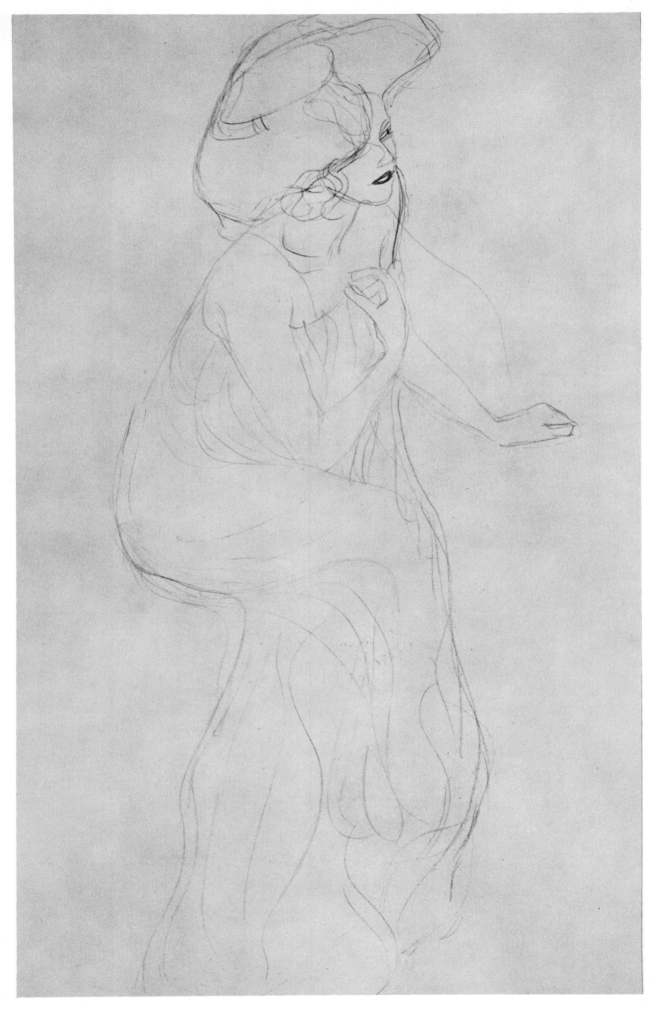

20. Portrait of a lady in a pleated dress and hat; c. 1903.

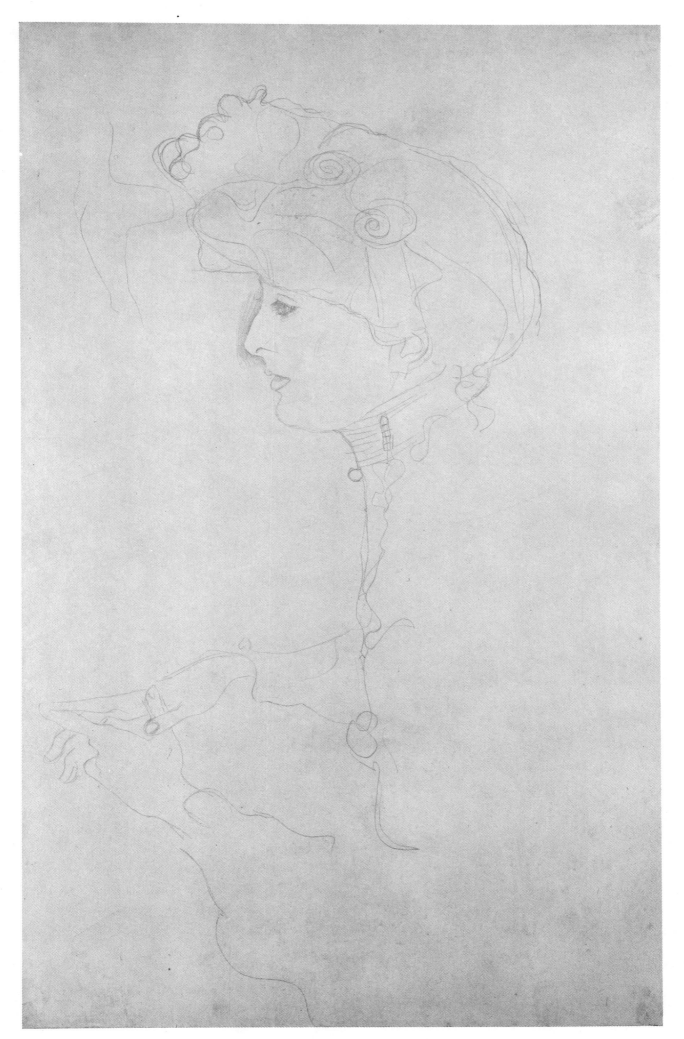

21. Profile portrait of a lady, facing left; c. 1904.

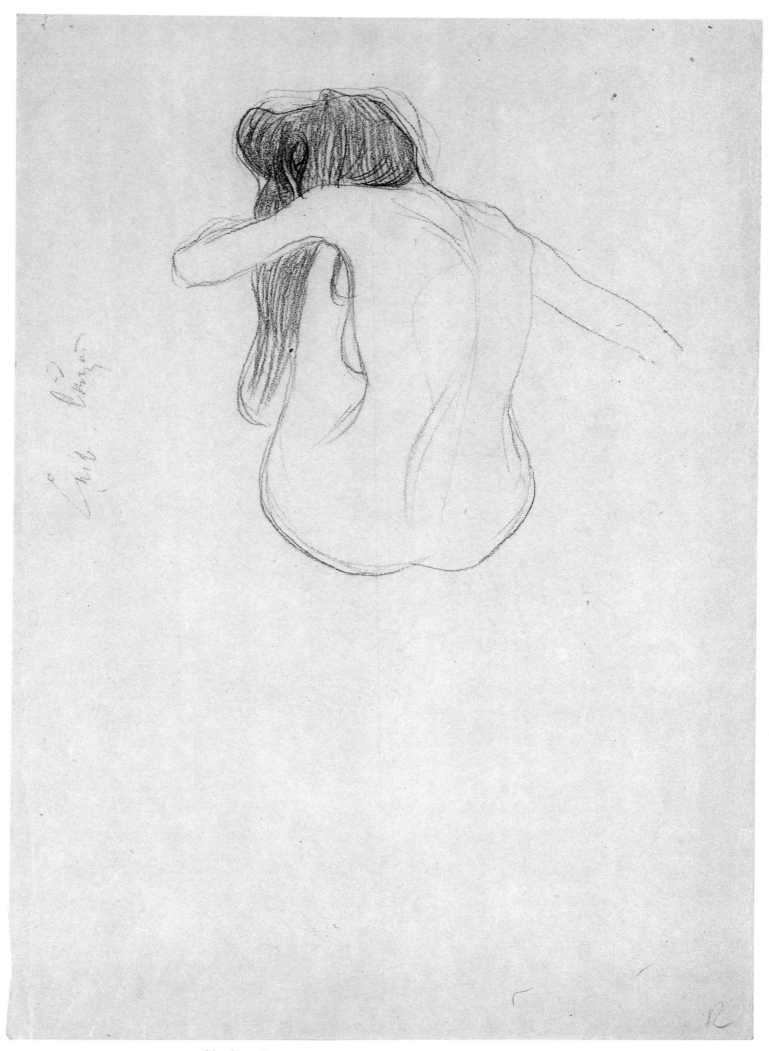

22. Seated nude with long hair, seen from behind; c. 1904.

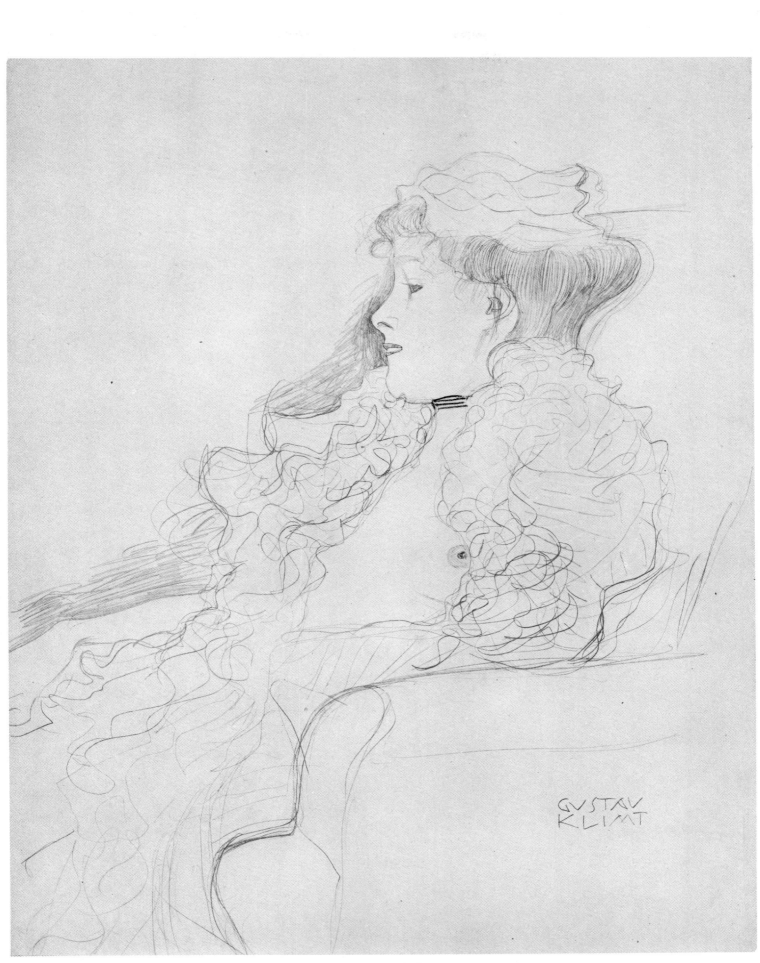

23. Seated girl facing left; c. 1904.

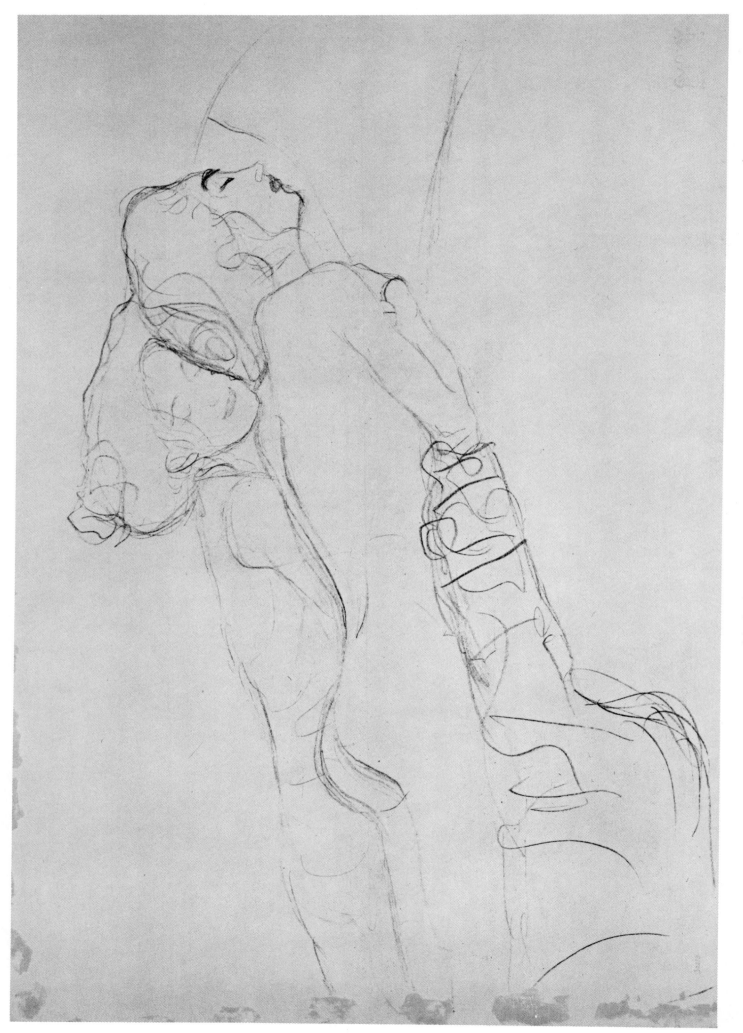

24. Study for *Water Serpents II*; c. 1904.

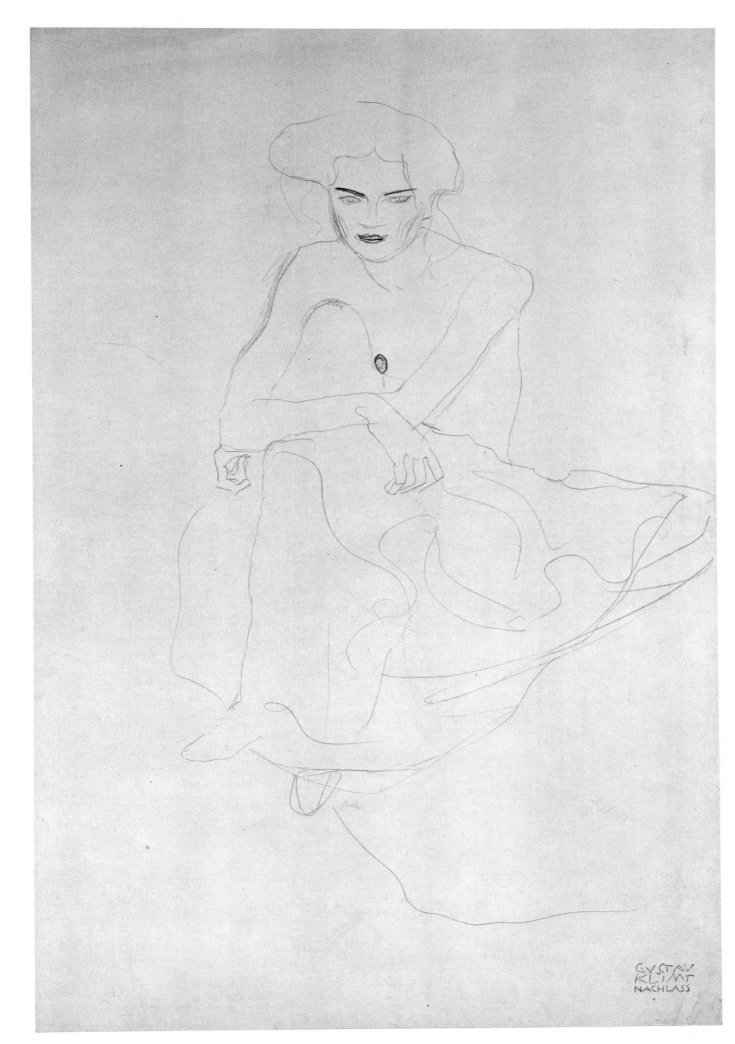

25. Seated woman with arms crossed; 1904/05.

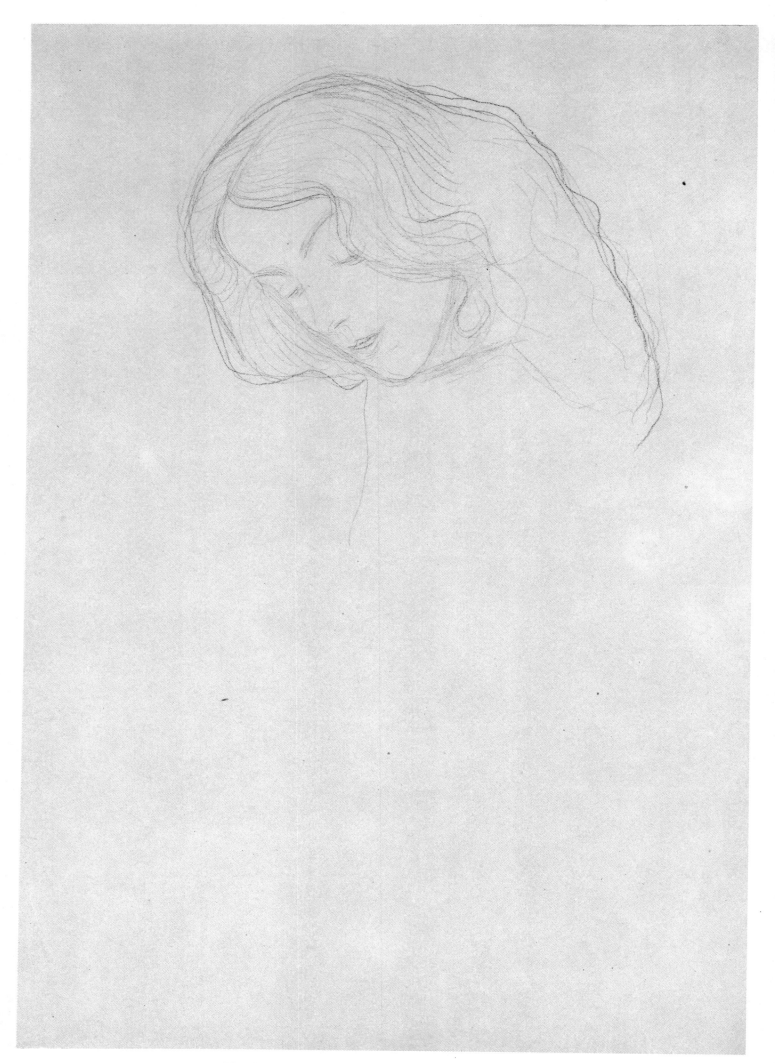

26. Head of a young woman looking down; 1904/06.

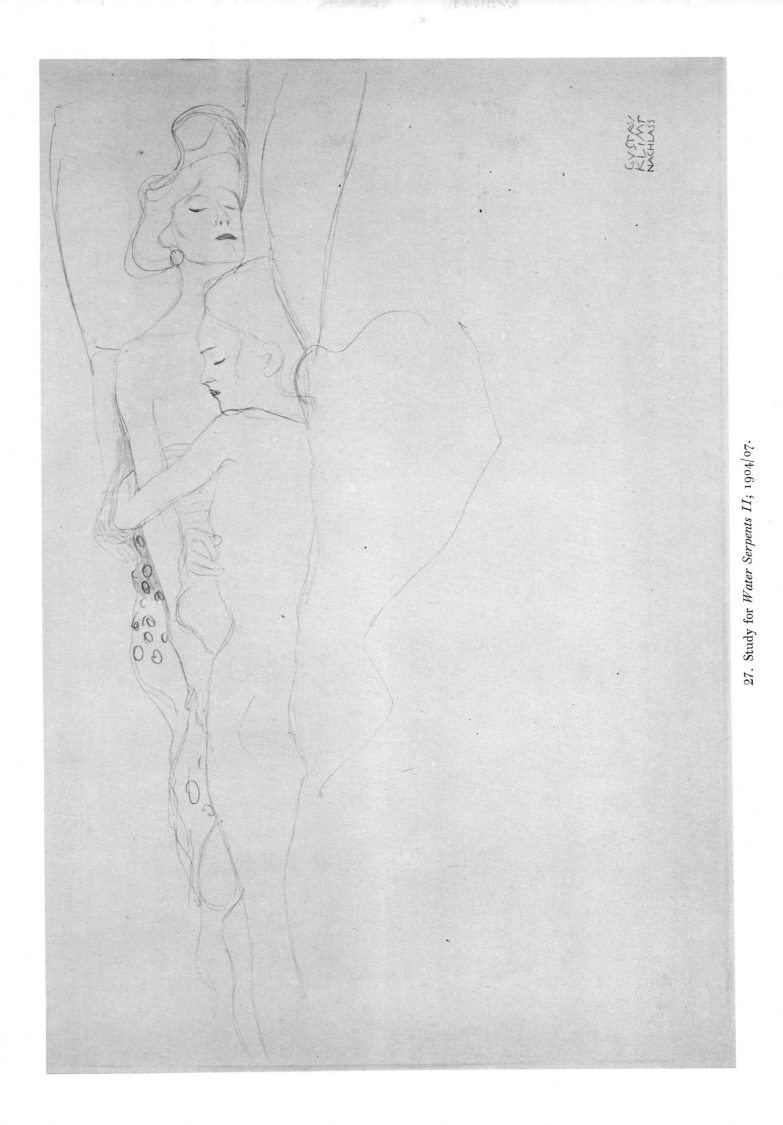

GVSTAV
KLIMT
NACHLASS

27. Study for *Water Serpents II*; 1904/07.

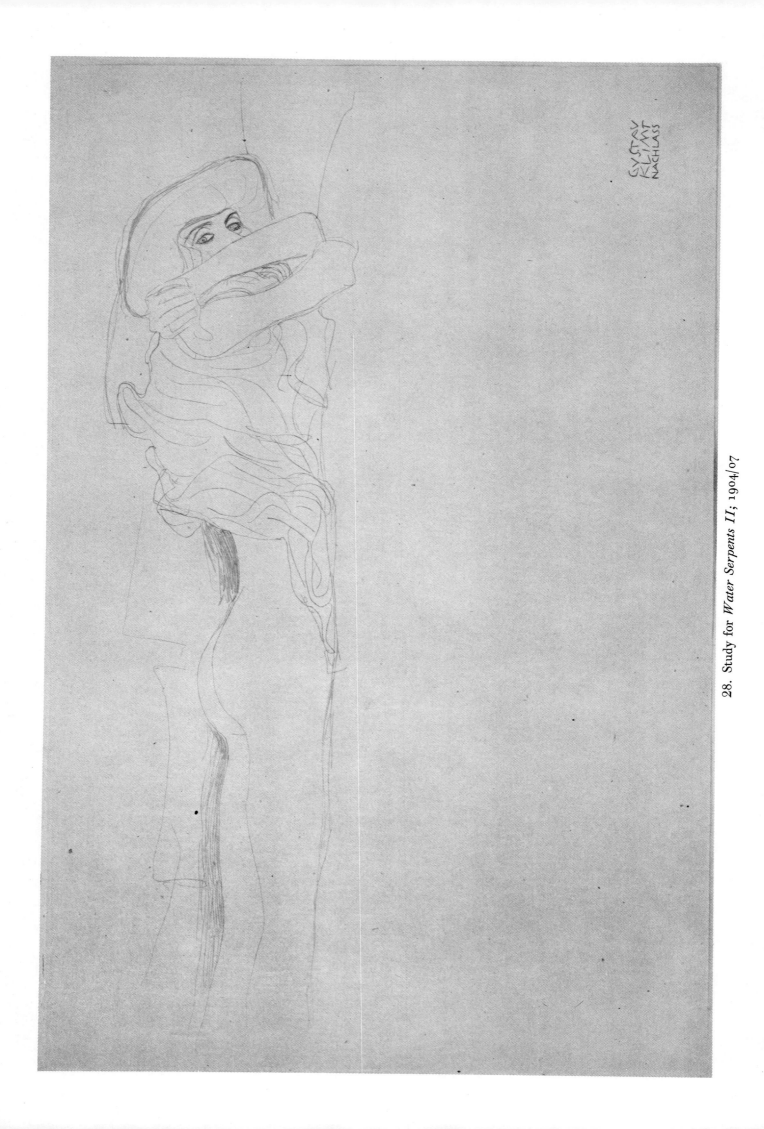

28. Study for *Water Serpents II;* 1904/07

GUSTAV
KLIMT
NACHLASS

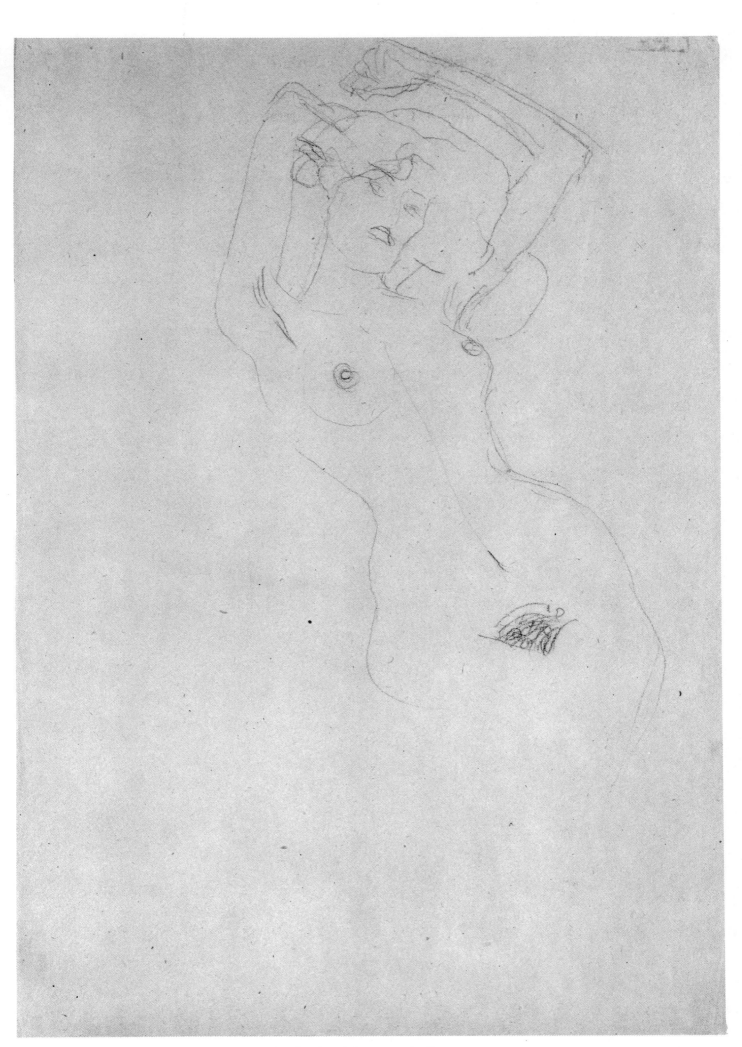

29. Nude with arms raised; c. 1905.

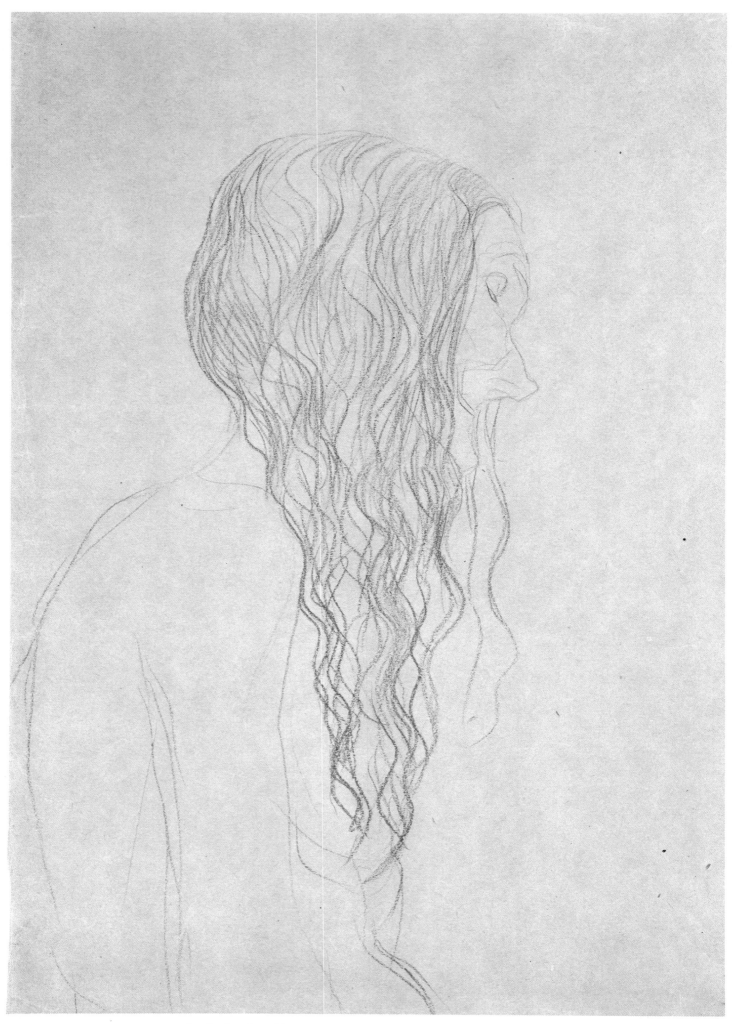

30. Study for the old woman in *The Three Ages of Woman*; c. 1905.

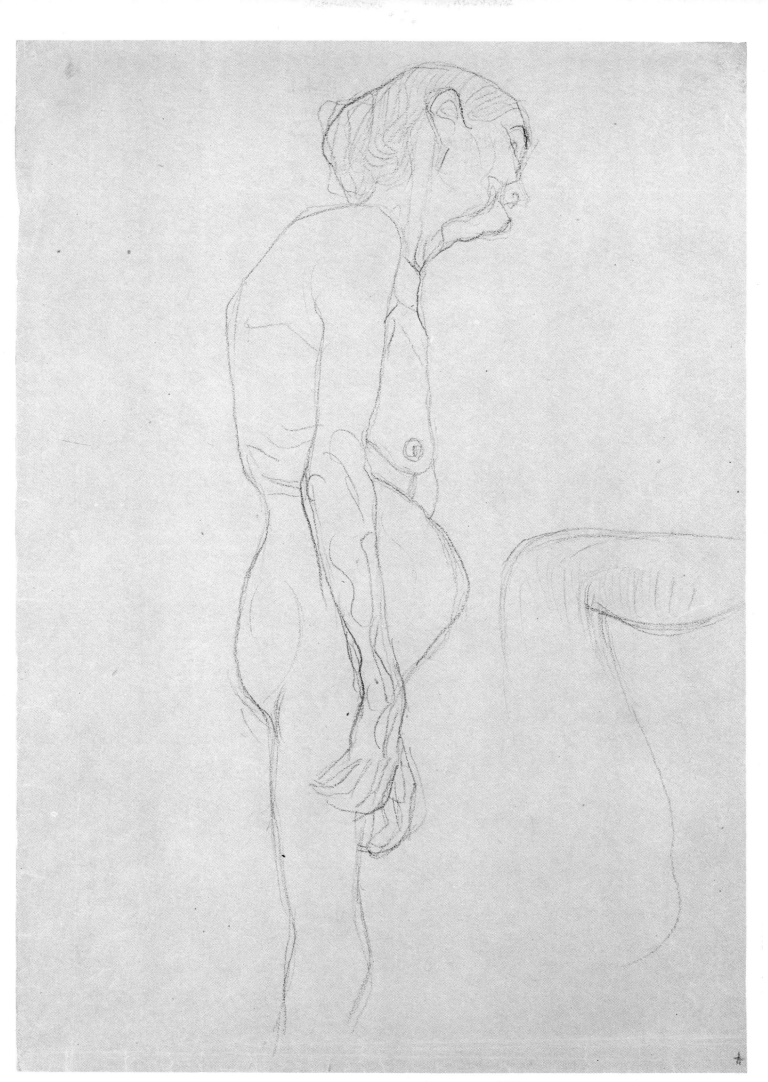

31. Study for the old woman in *The Three Ages of Woman*; c. 1905.

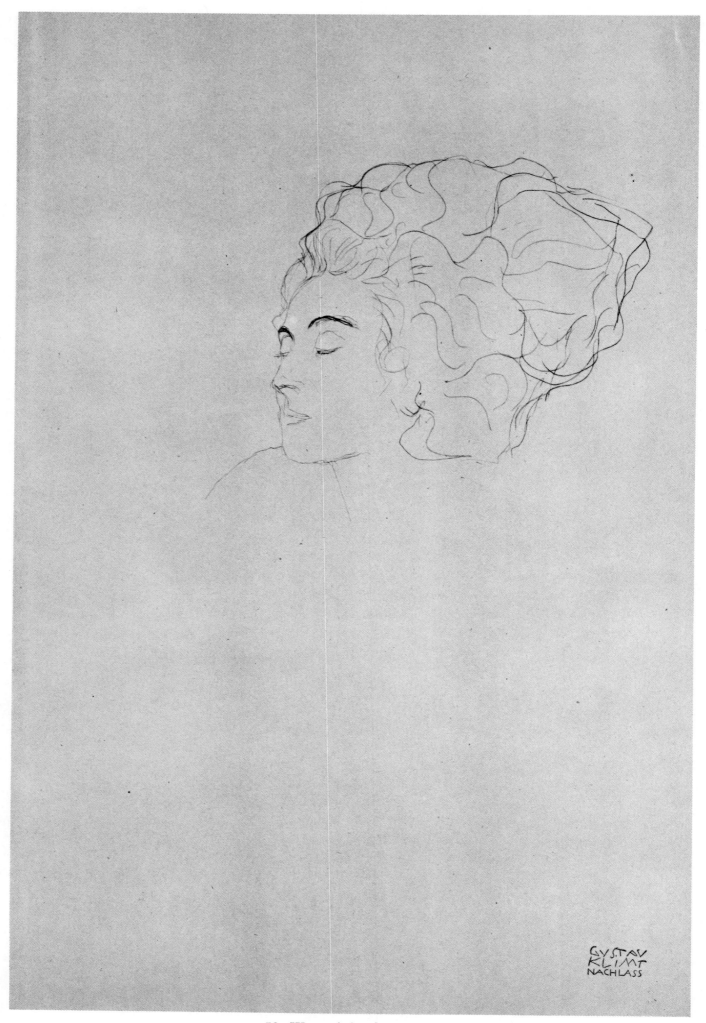

32. Woman's head; c. 1905.

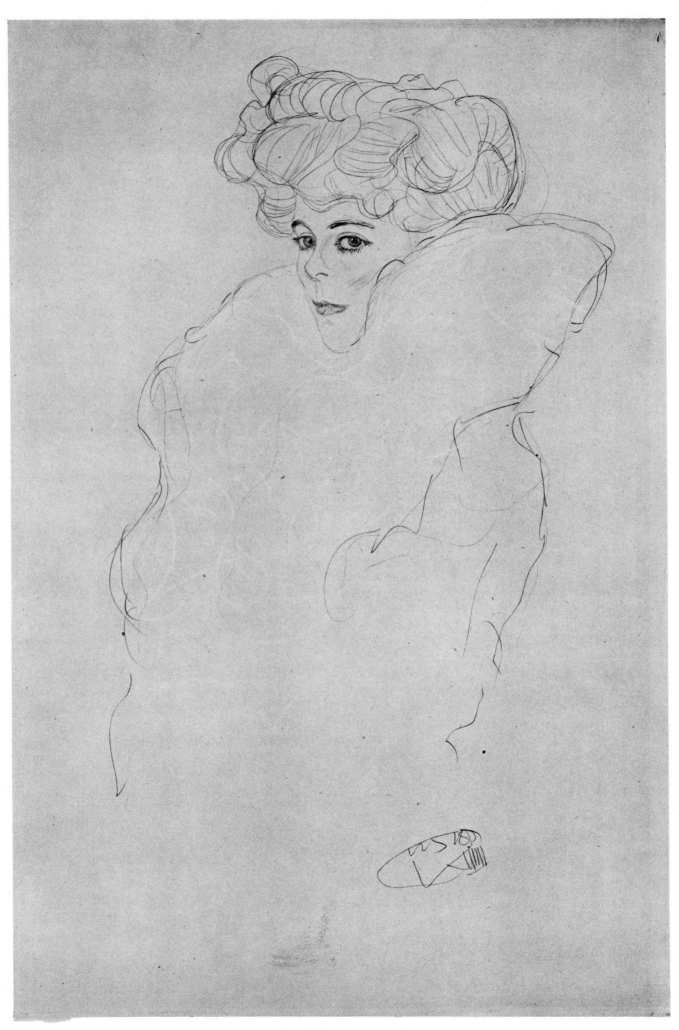

33. Portrait sketch of lady wearing a boa; c. 1905.

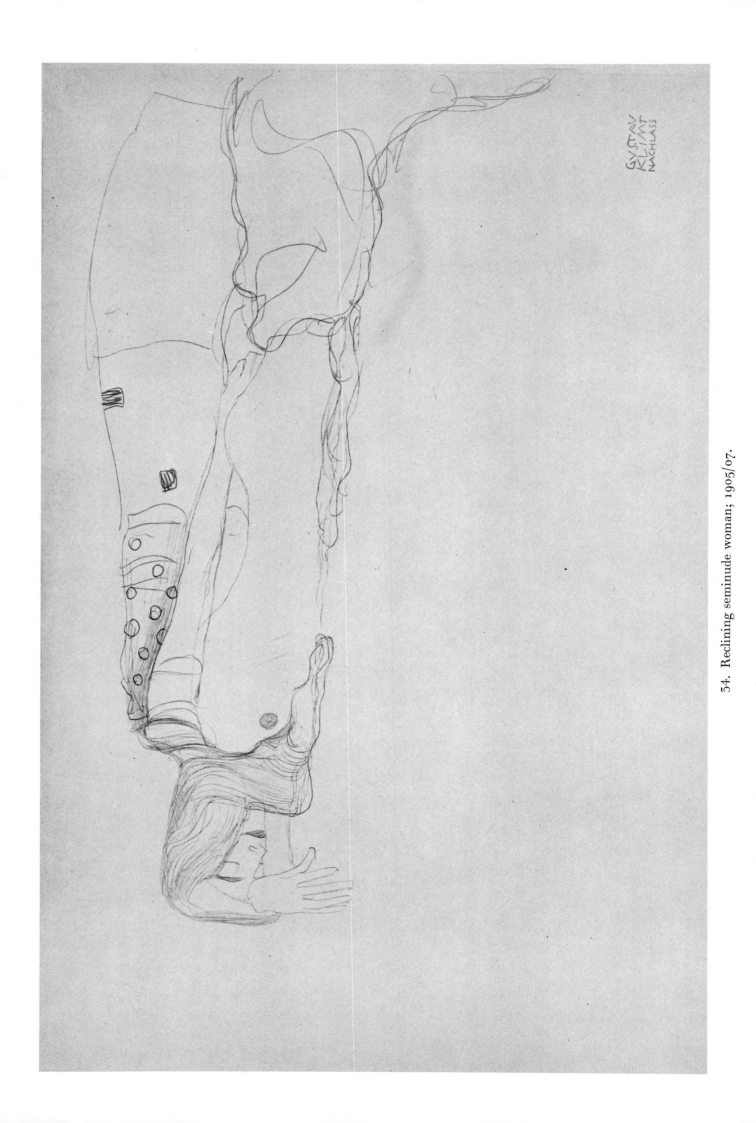

34. Reclining seminude woman; 1905/07.

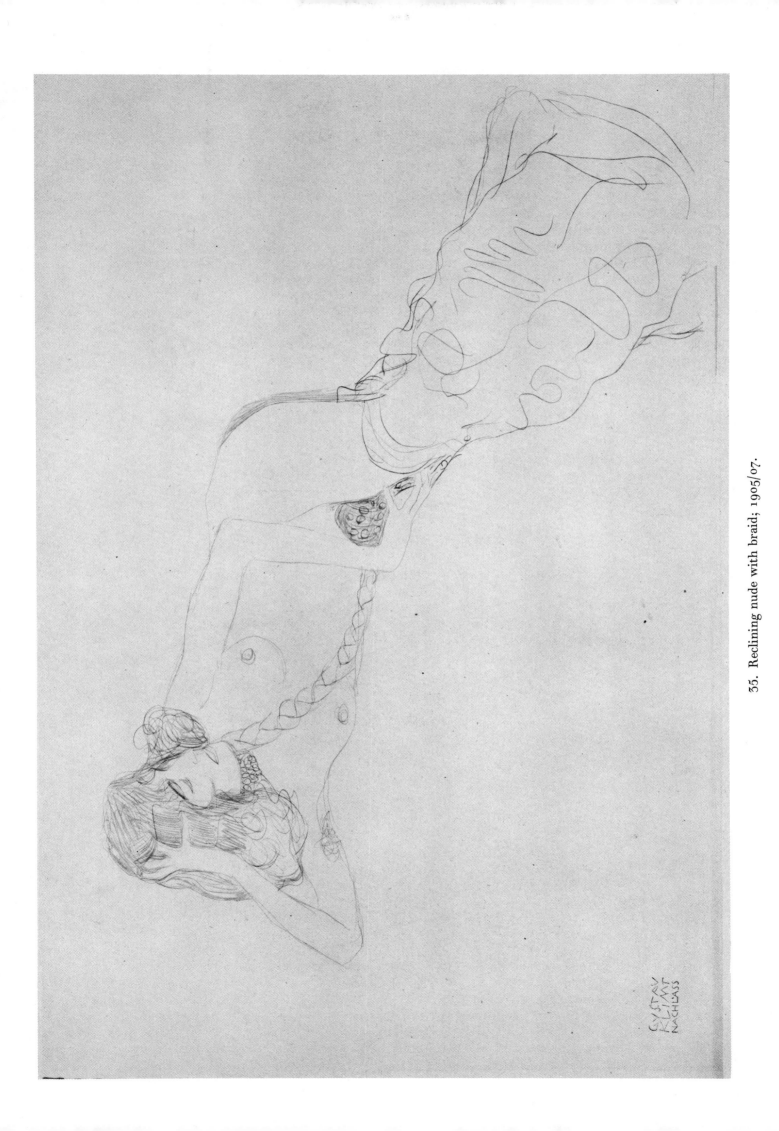

35. Reclining nude with braid; 1905/07.

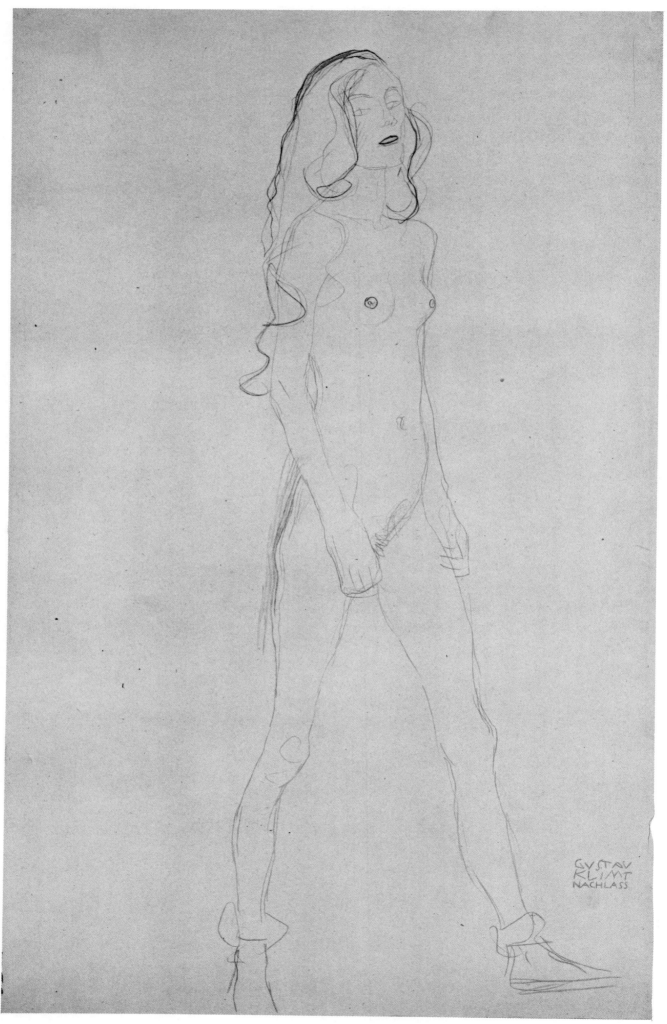

36. Standing nude; 1905/07.

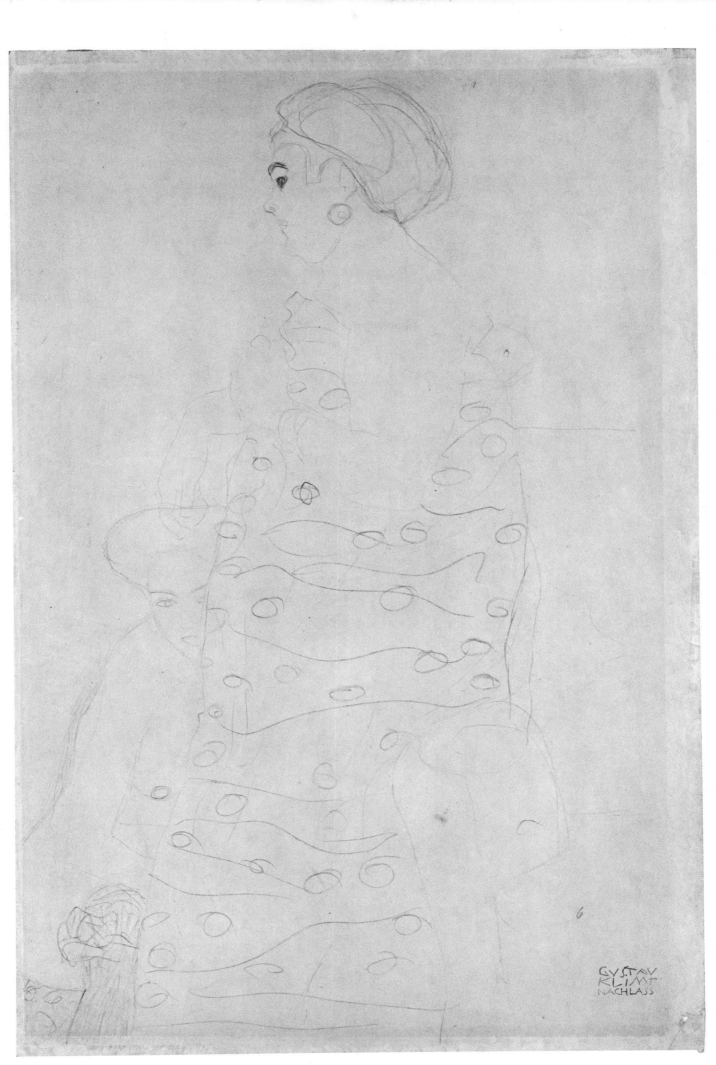

37. Two female figures; 1905/07.

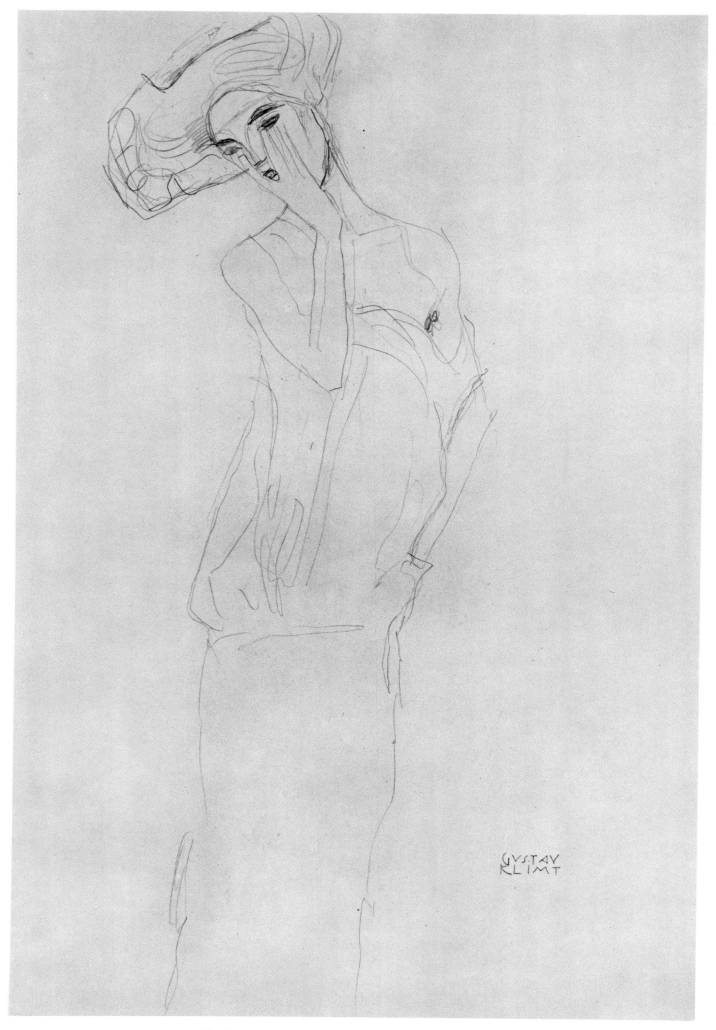

38. Front view of standing female figure; 1905/07.

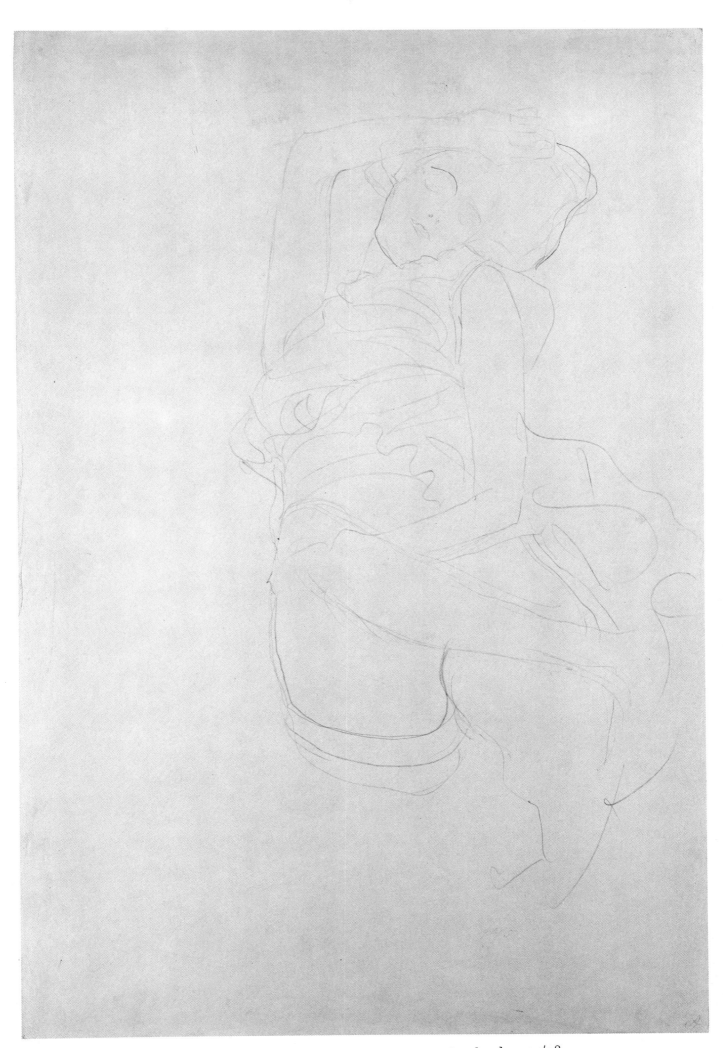

39. Reclining woman with her right arm over her head; 1905/08.

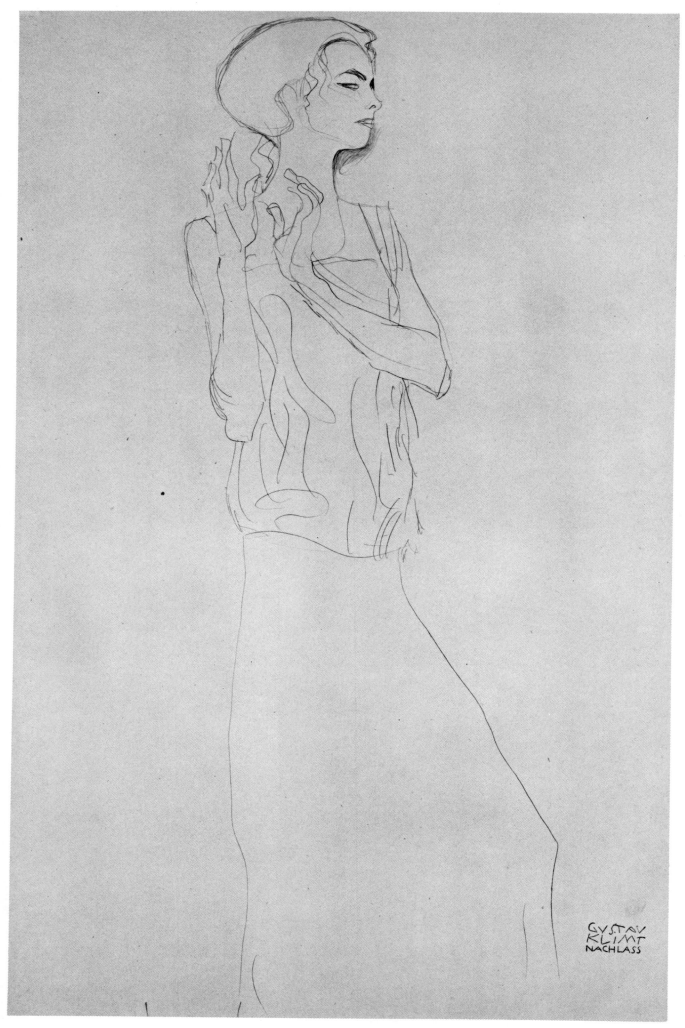

40. Study for a frieze in the Palais Stoclet, Brussels; 1905/11.

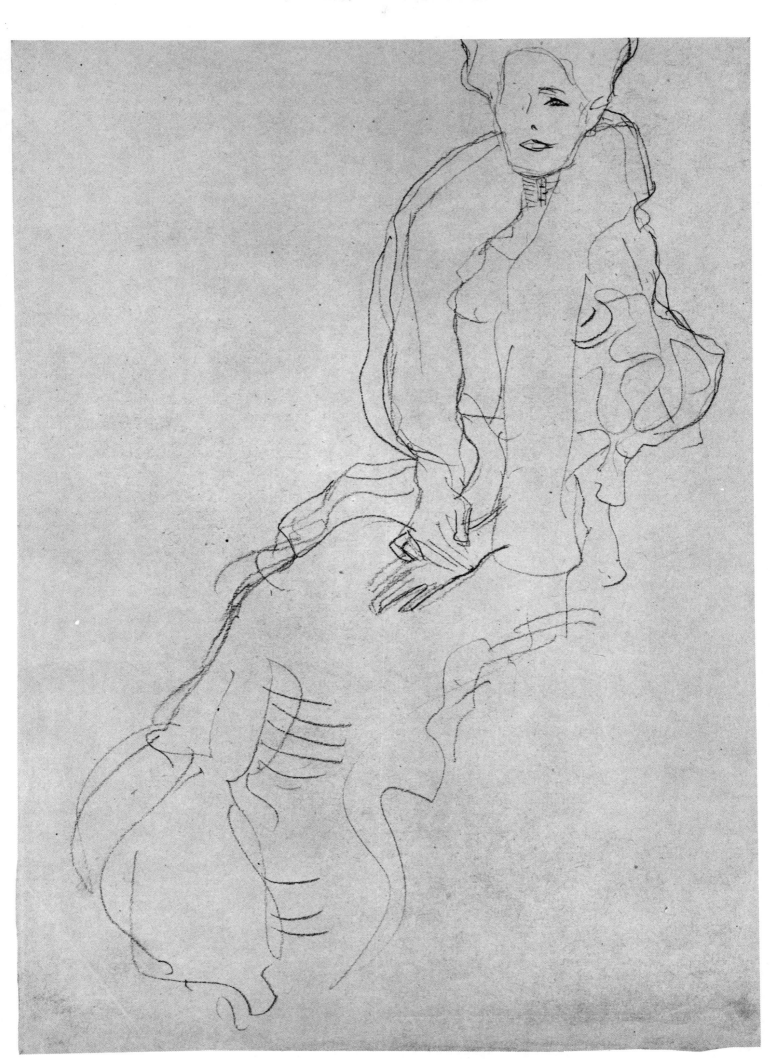

41. Study for the portrait of Fritza Riedler (1906).

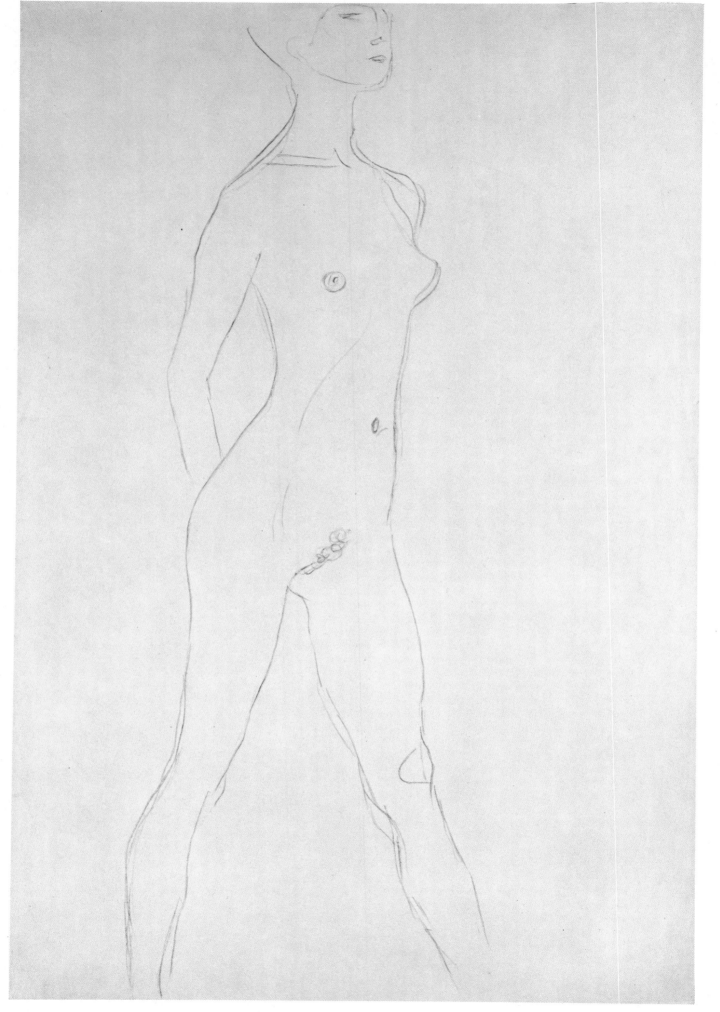

42. Standing nude in three-quarter view; c. 1906.

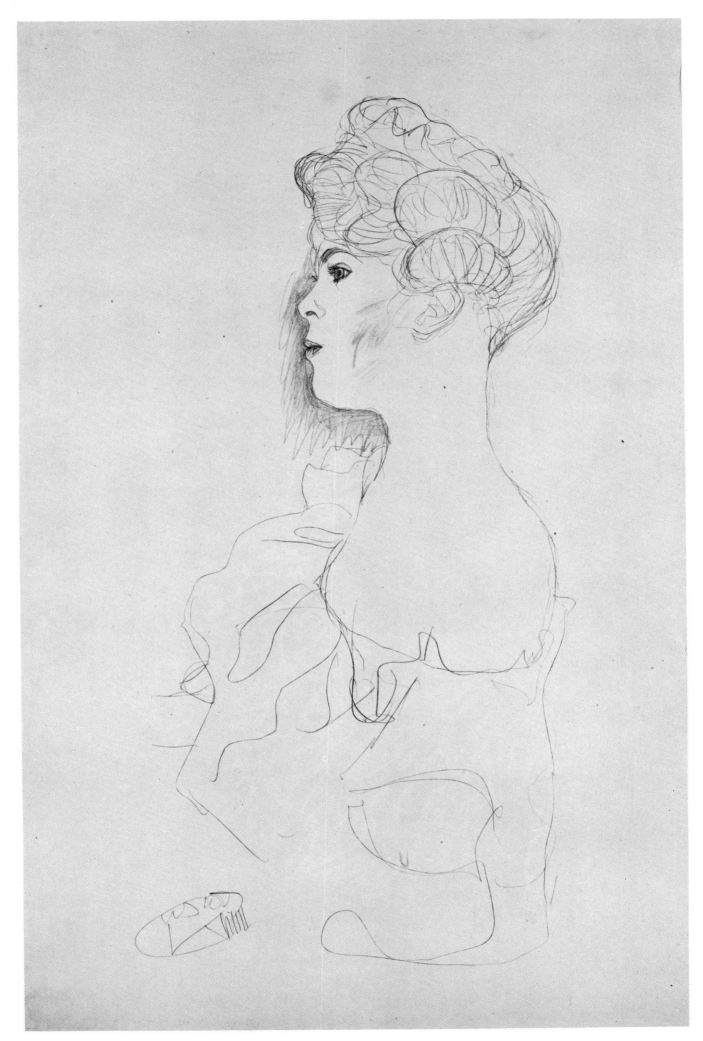

43. Portrait of a woman; c. 1906.

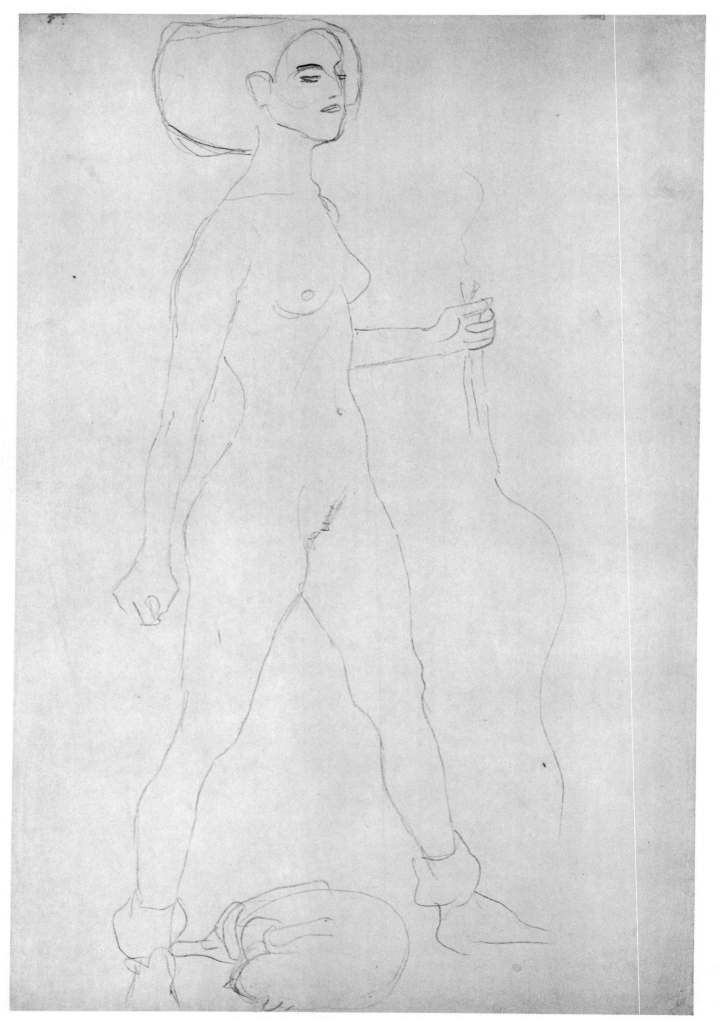

44. Standing nude with cello; c. 1906.

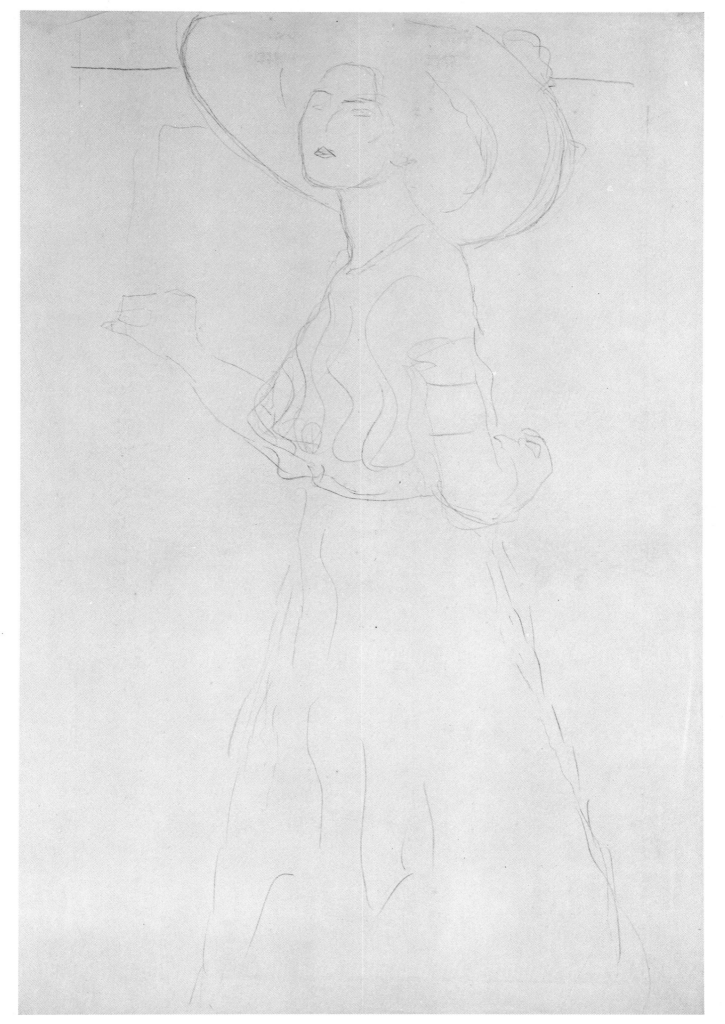

45. Woman in large hat, facing left; c. 1906.

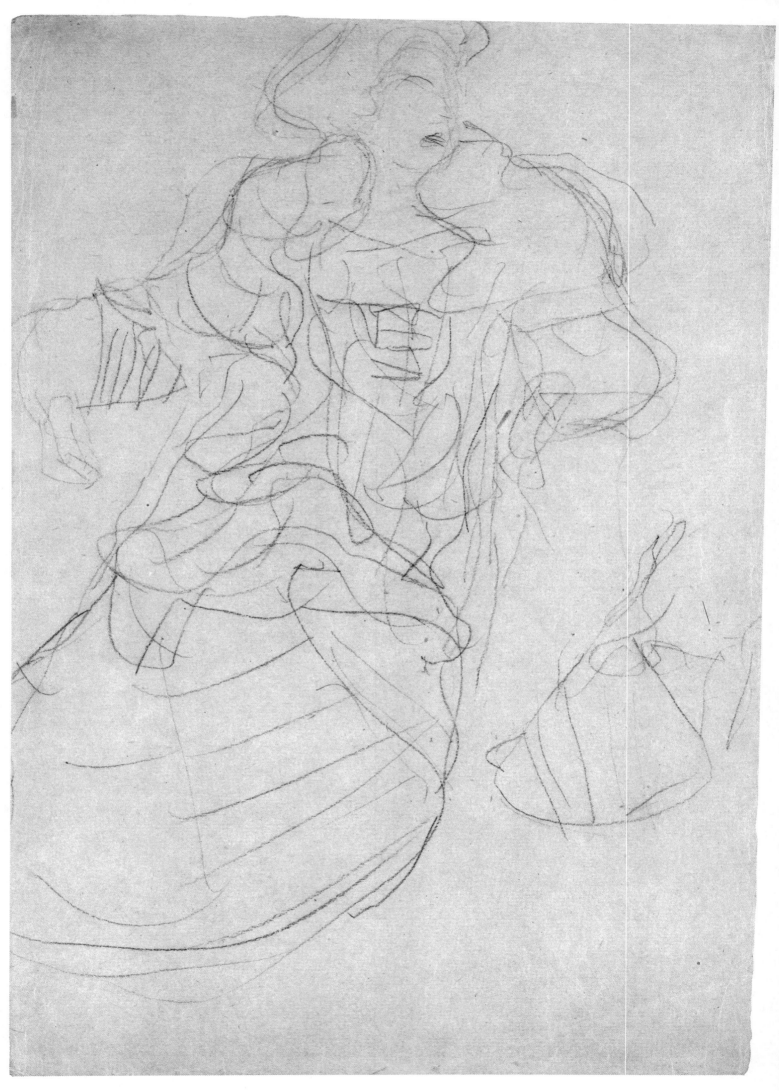

46. Seated woman in gown; c. 1906.

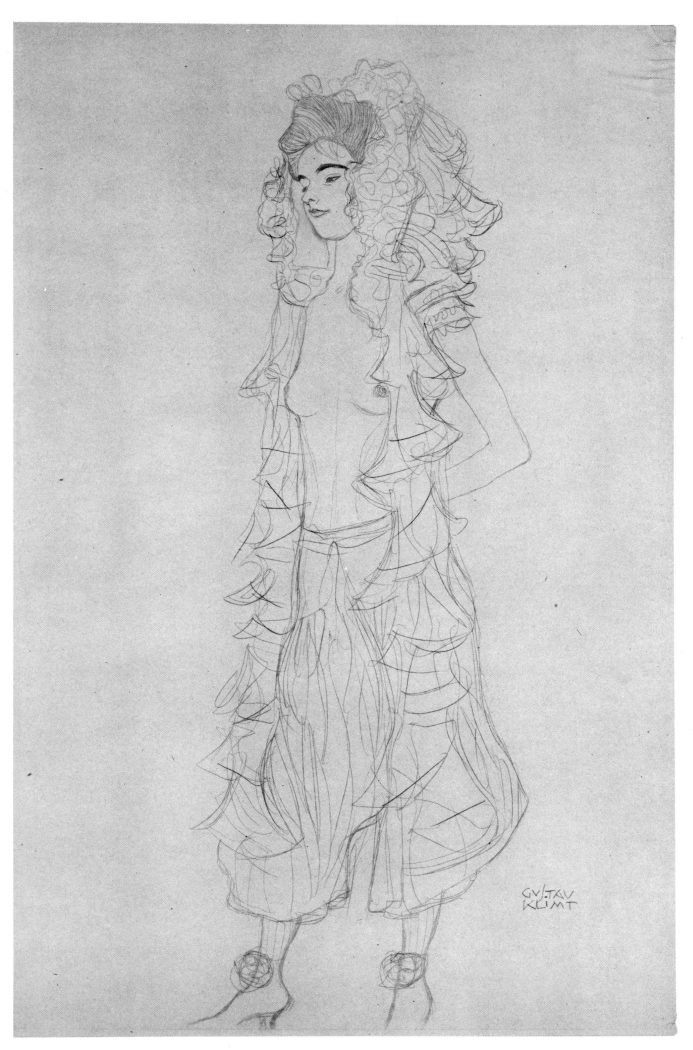

47. Standing girl with lace headdress; c. 1907.

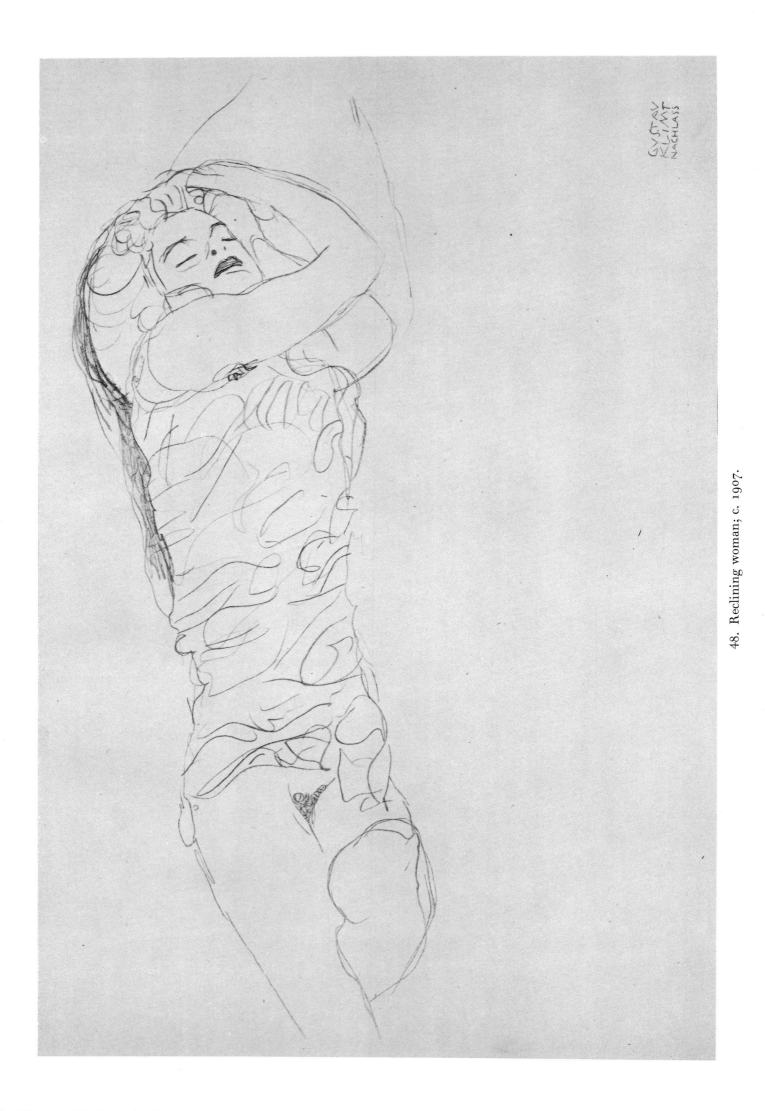

48. Reclining woman; c. 1907.

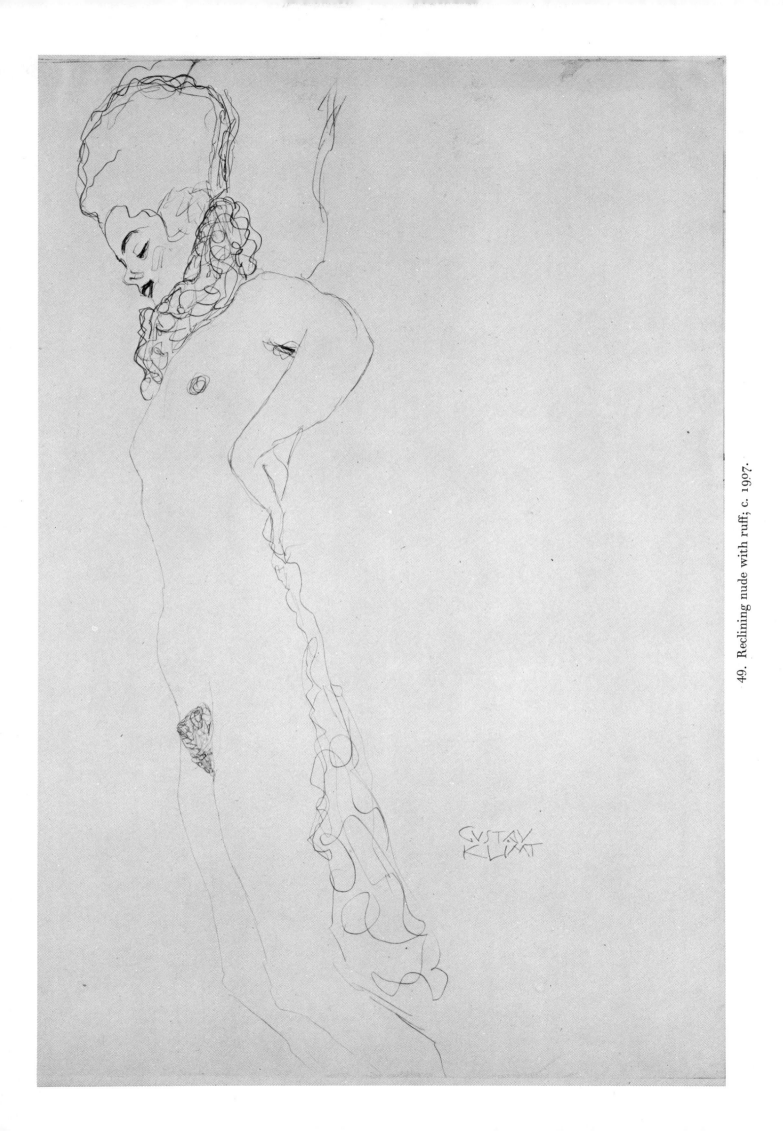

49. Reclining nude with ruff; c. 1907.

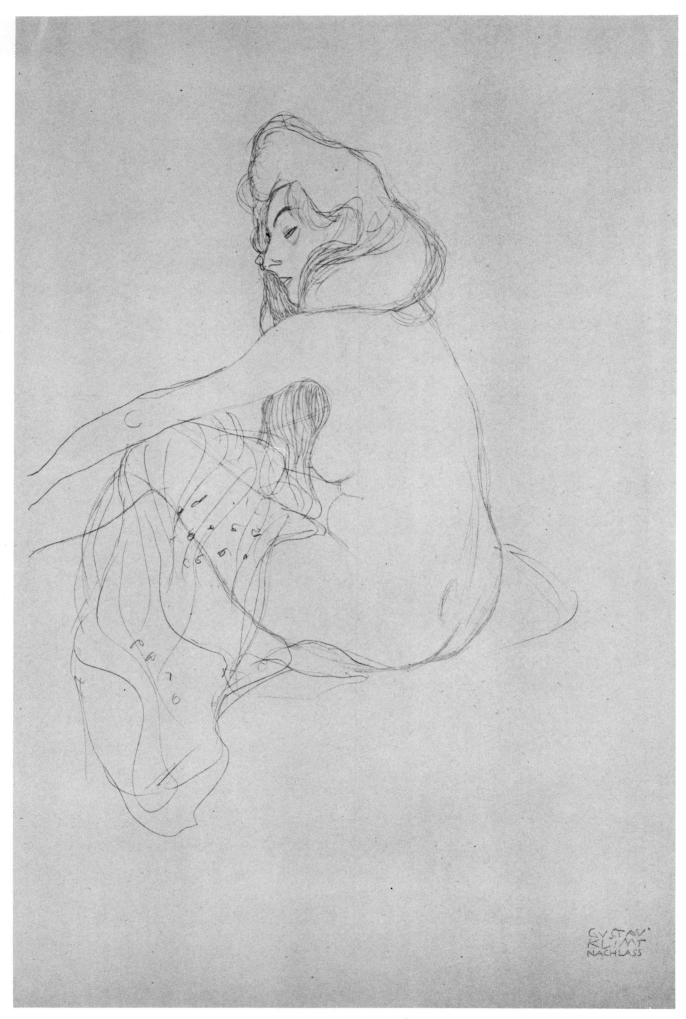

50. Early study for the painting *Danaë* (c. 1907–08).

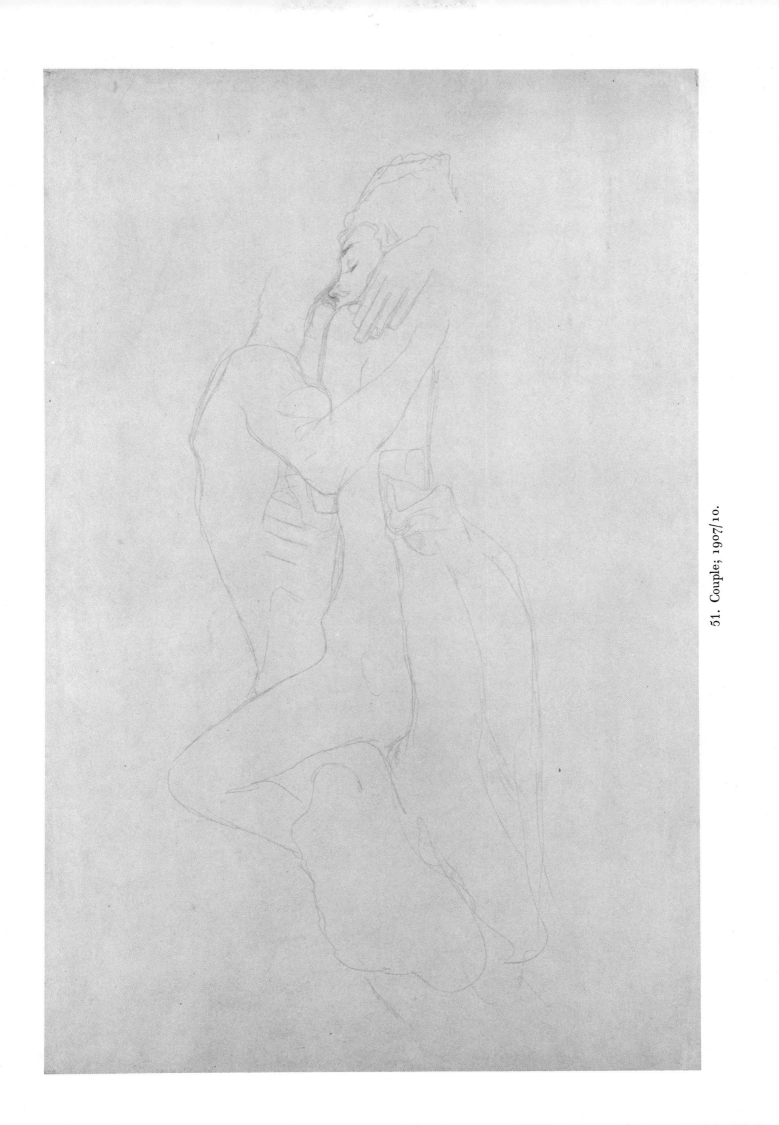

51. Couple; 1907/10.

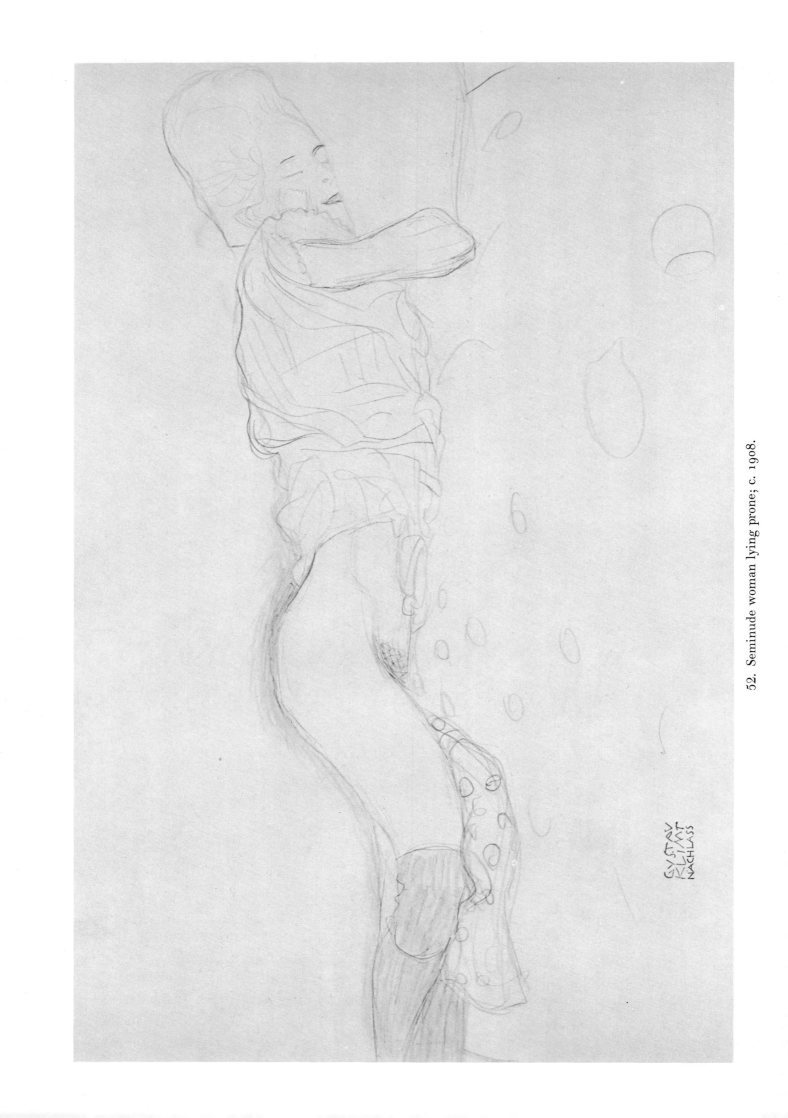

52. Seminude woman lying prone; c. 1908.

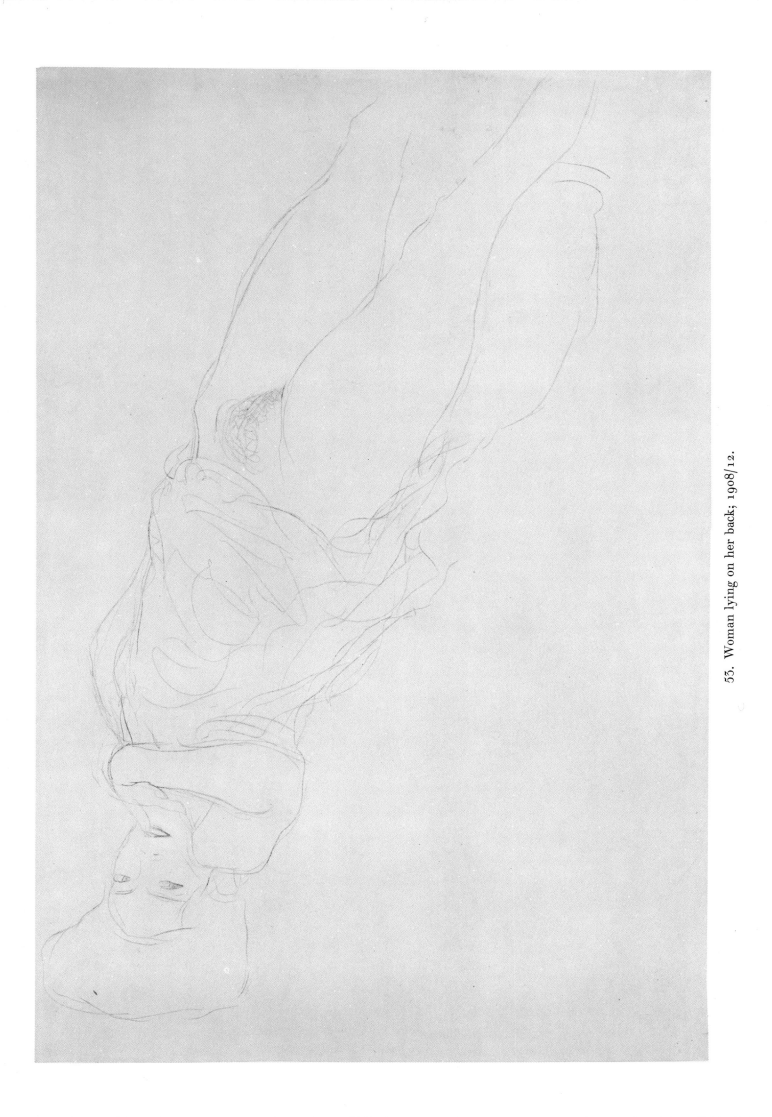

53. Woman lying on her back; 1908/12.

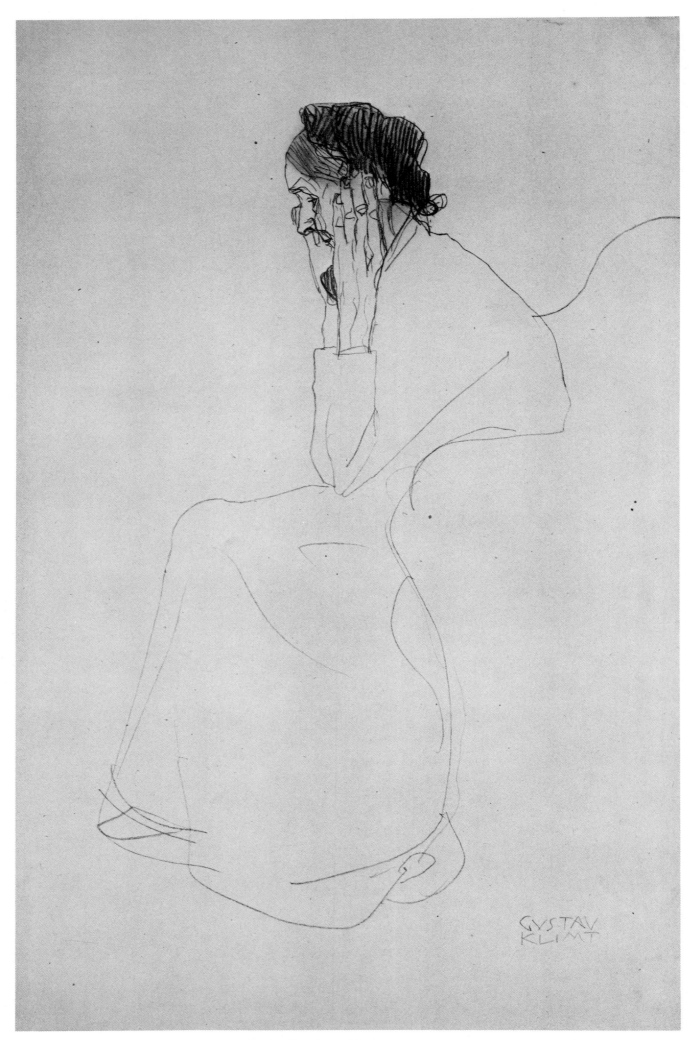

54. Study of an old woman; c. 1909.

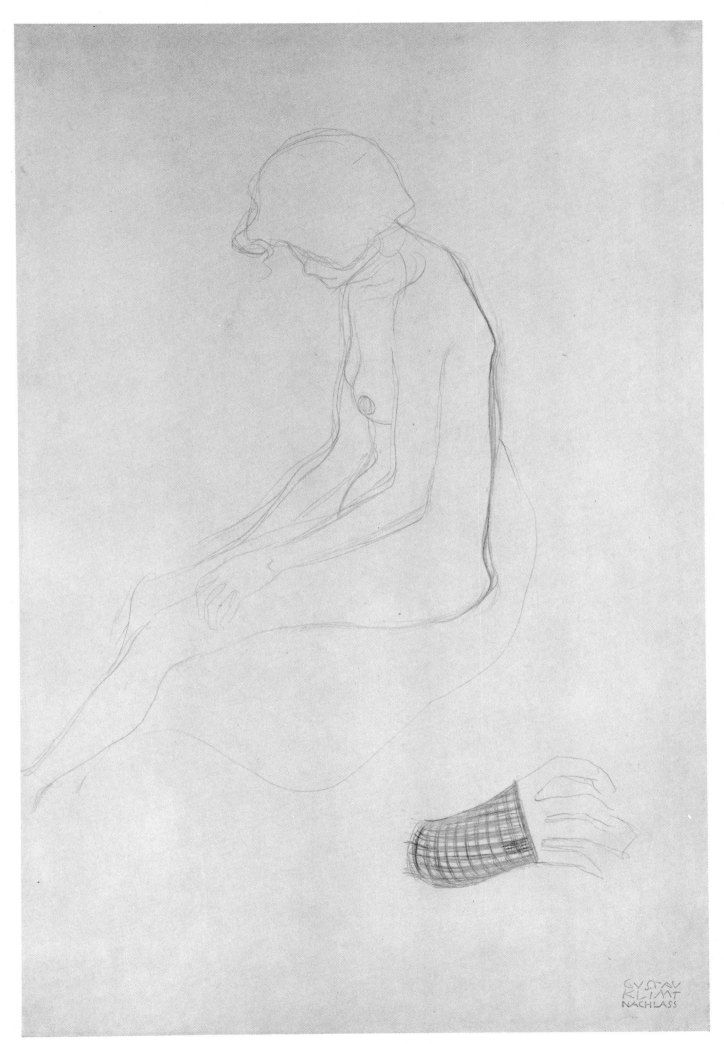

55. Seated nude looking down; study of hand; c. 1910.

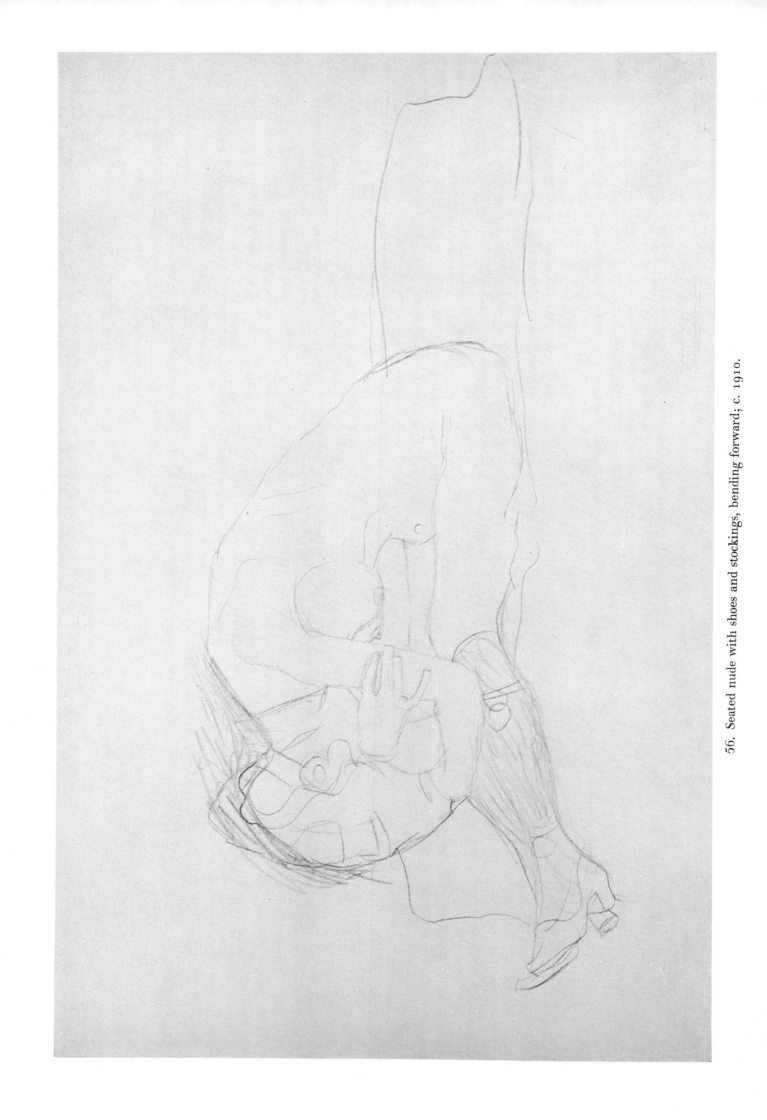

56. Seated nude with shoes and stockings, bending forward; c. 1910.

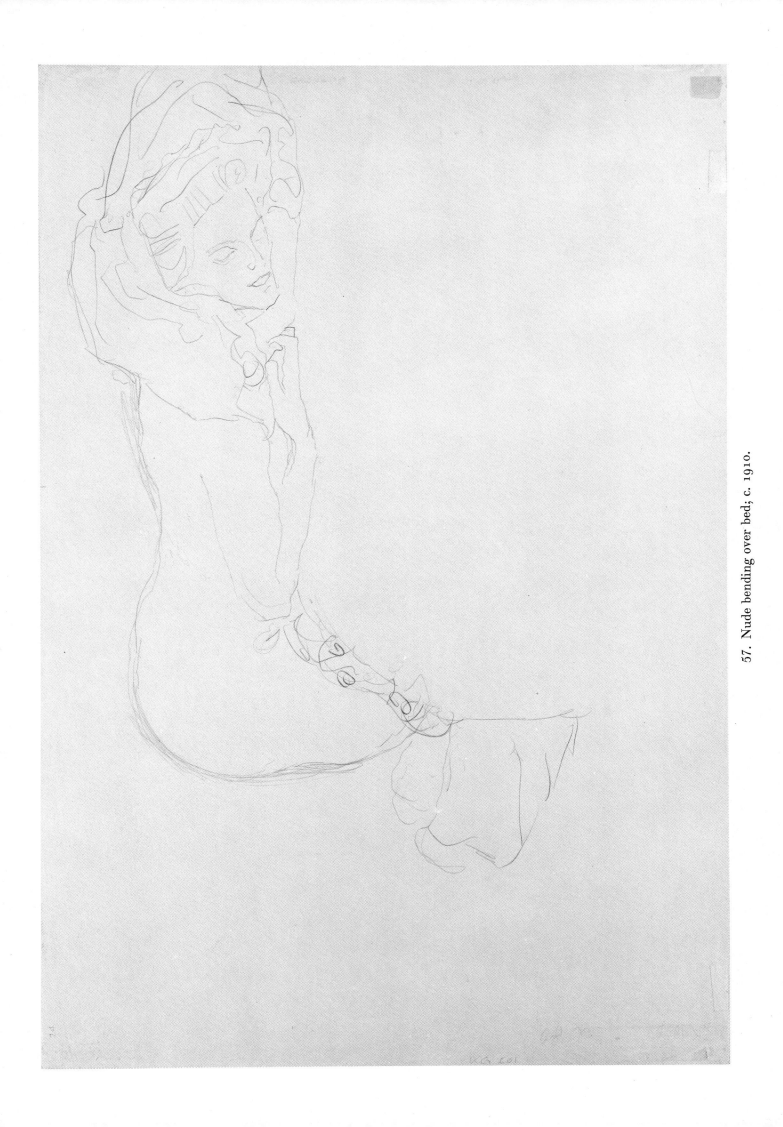

57. Nude bending over bed; c. 1910.

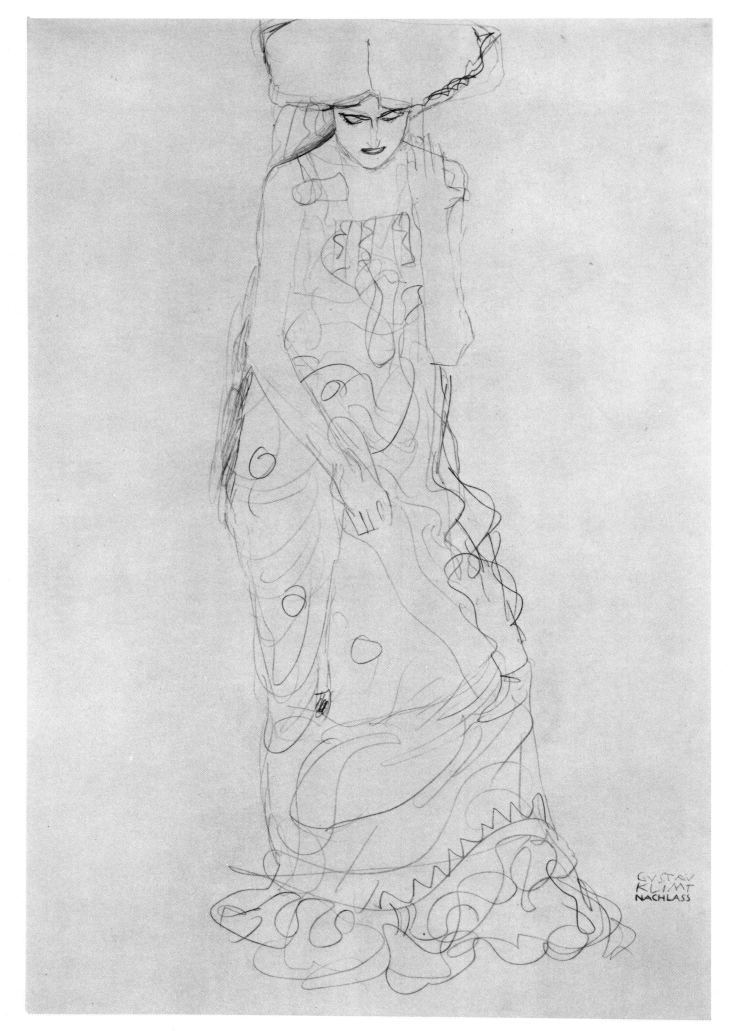

58. Front view of standing woman; c. 1910.

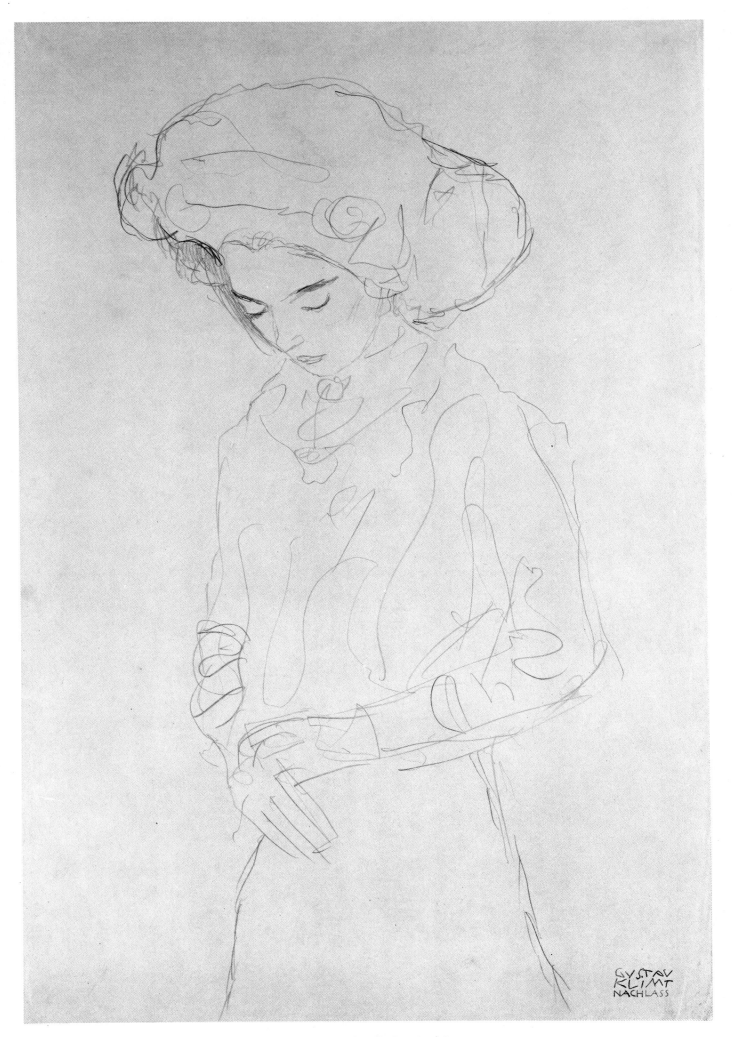

59. Portrait sketch of a lady looking down; c. 1910.

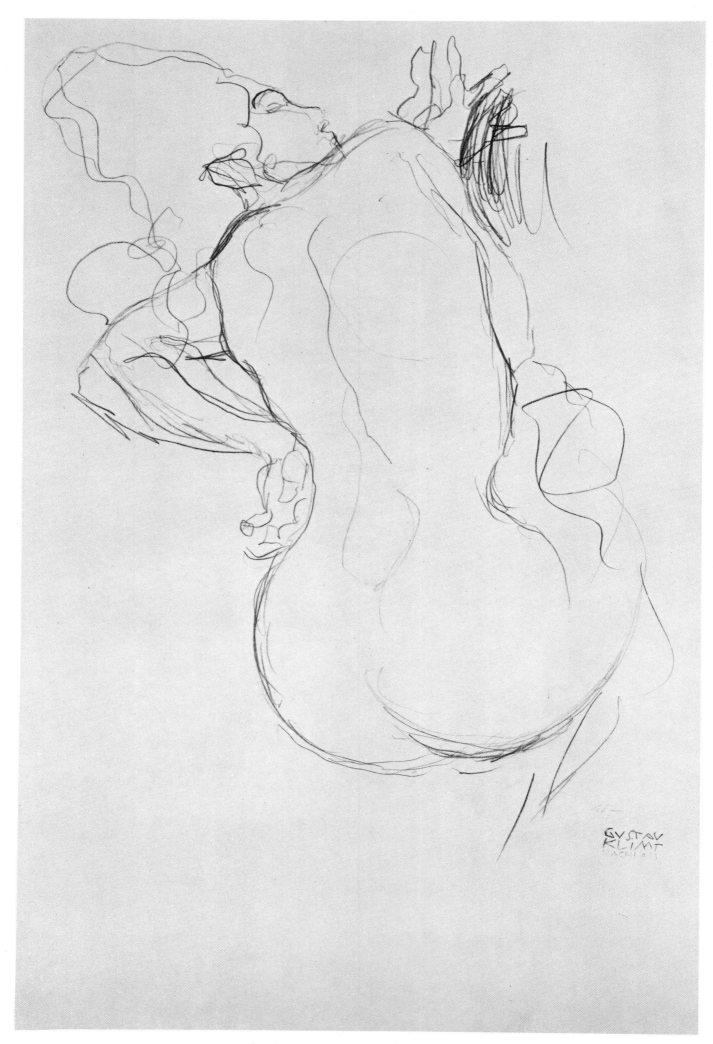

60. Nude seen from behind; c. 1910.

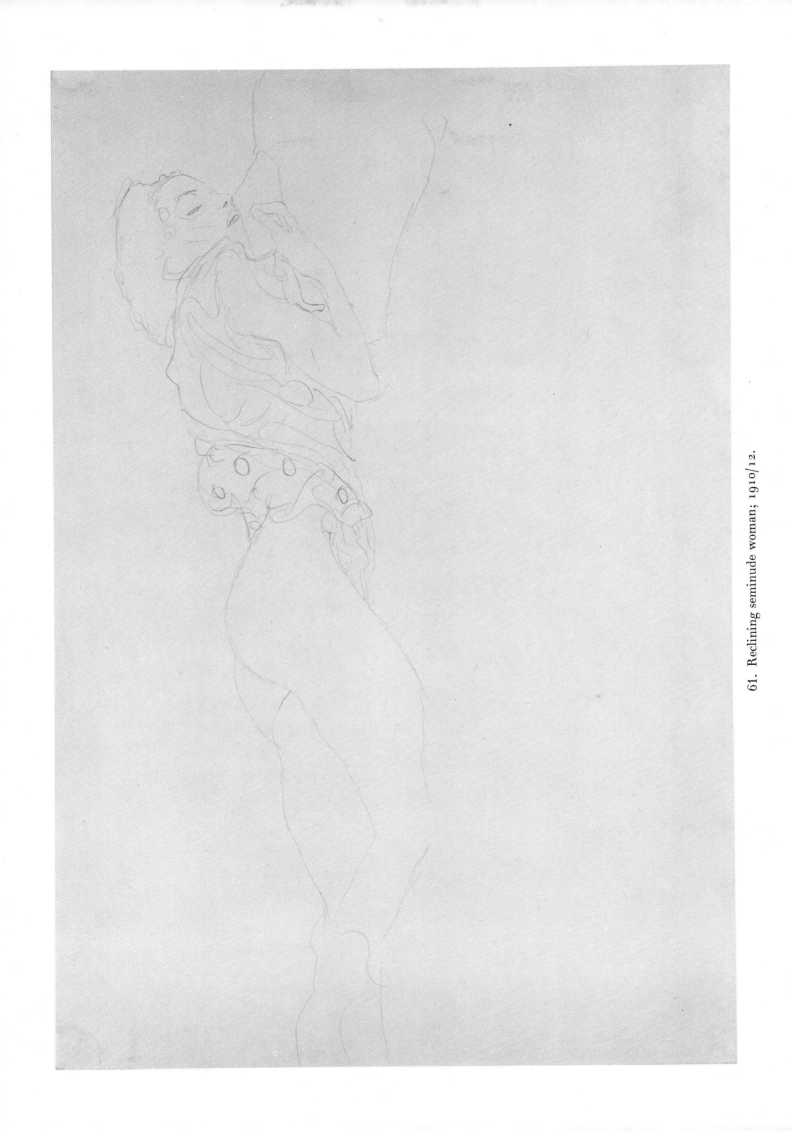

61. Reclining seminude woman; 1910/12.

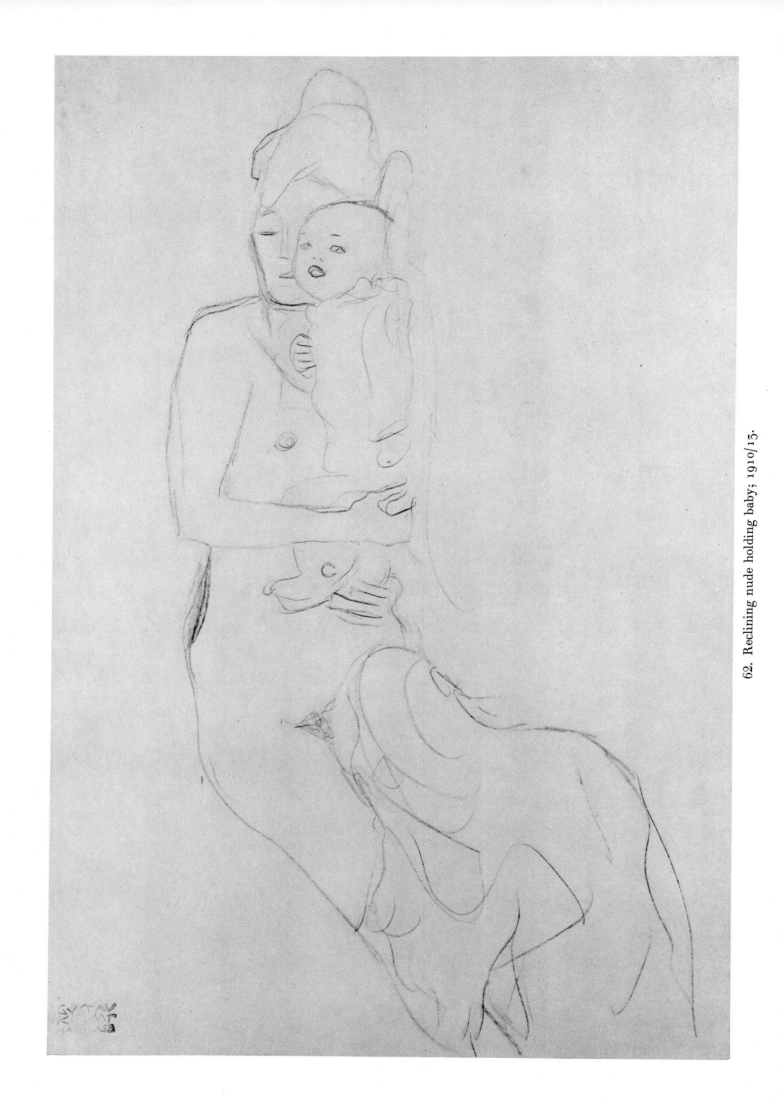

62. Reclining nude holding baby; 1910/13.

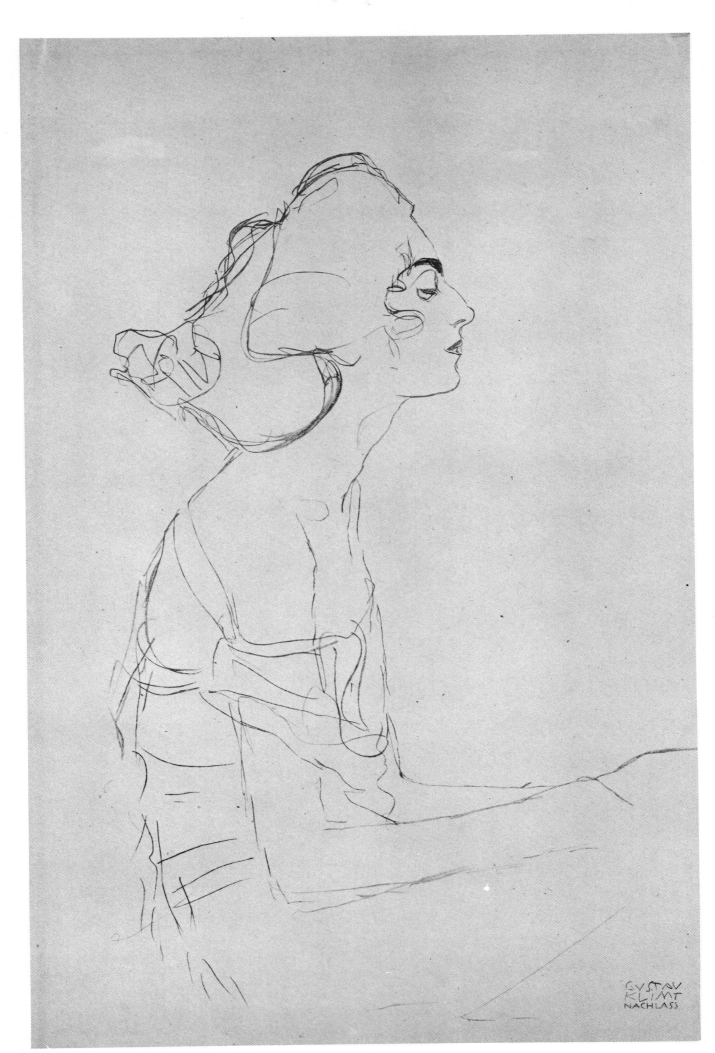

63. Seated woman, half length; 1910/15.

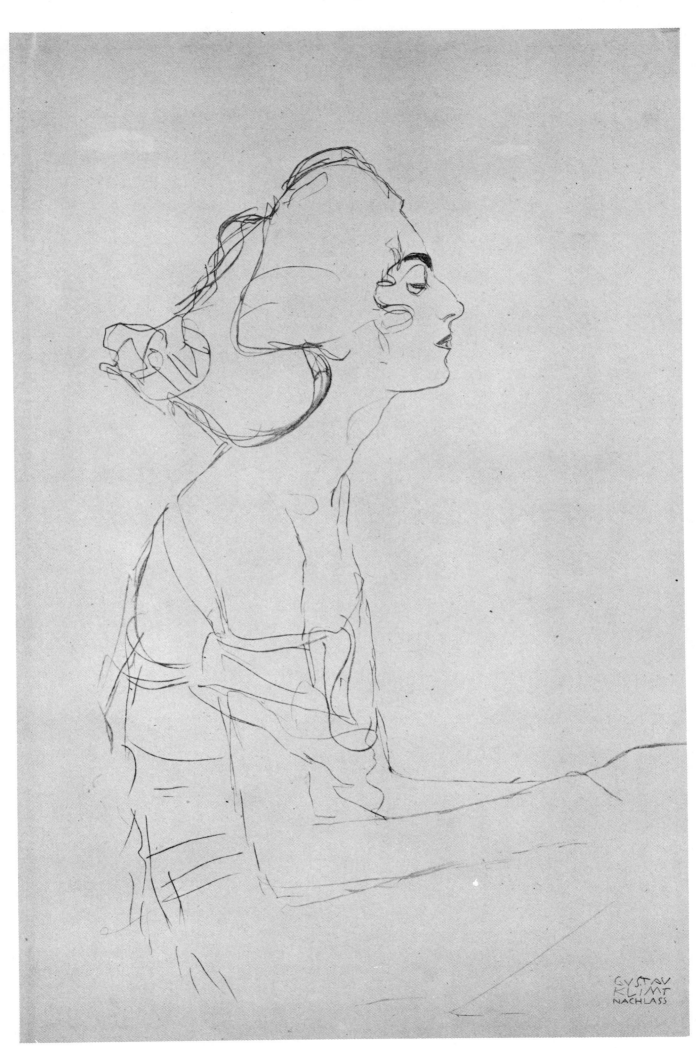

63. Seated woman, half length; 1910/15.

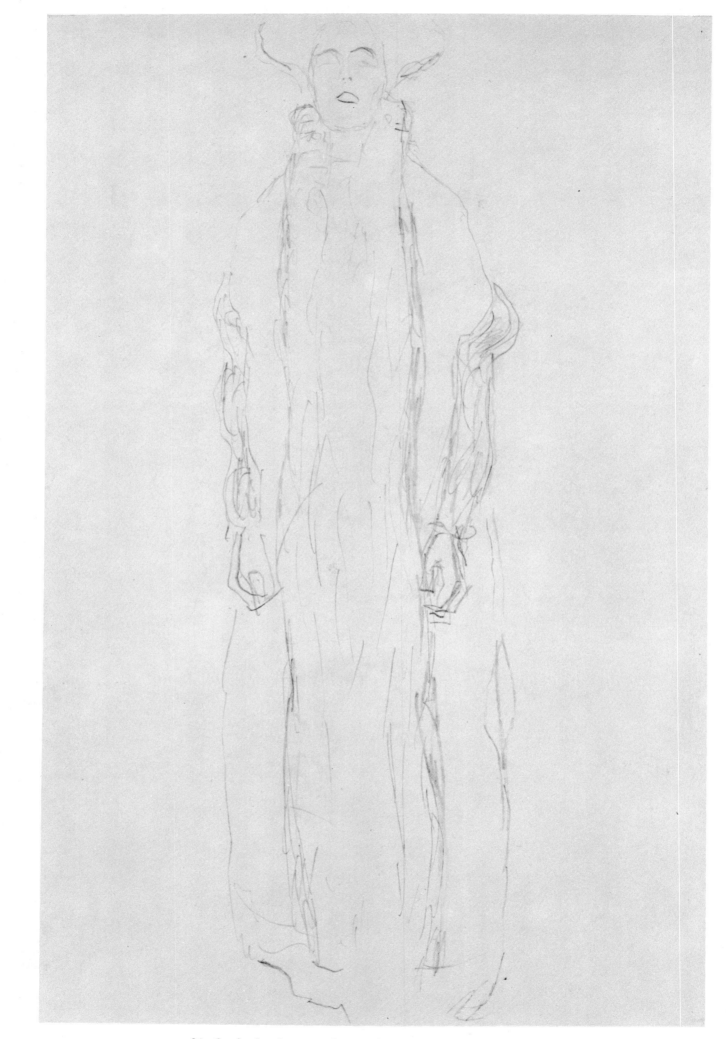

64. Study for the second portrait of Adele Bloch-Bauer (1912).

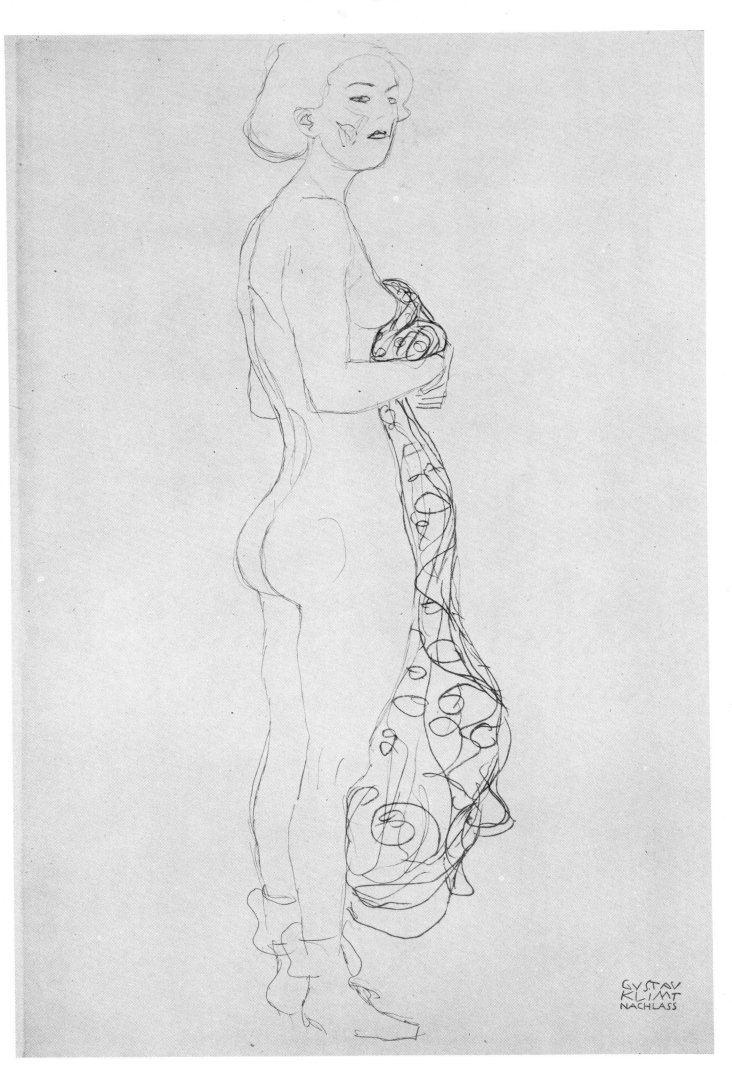

65. Standing nude; c. 1912.

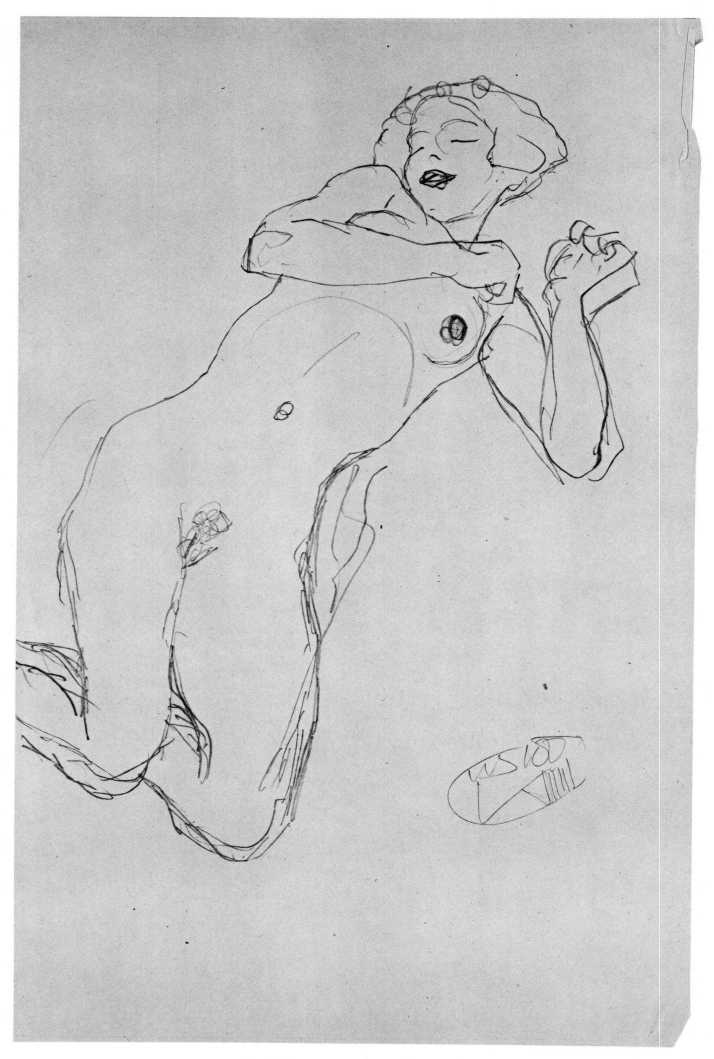

66. Study for *The Maiden* (1912–13).

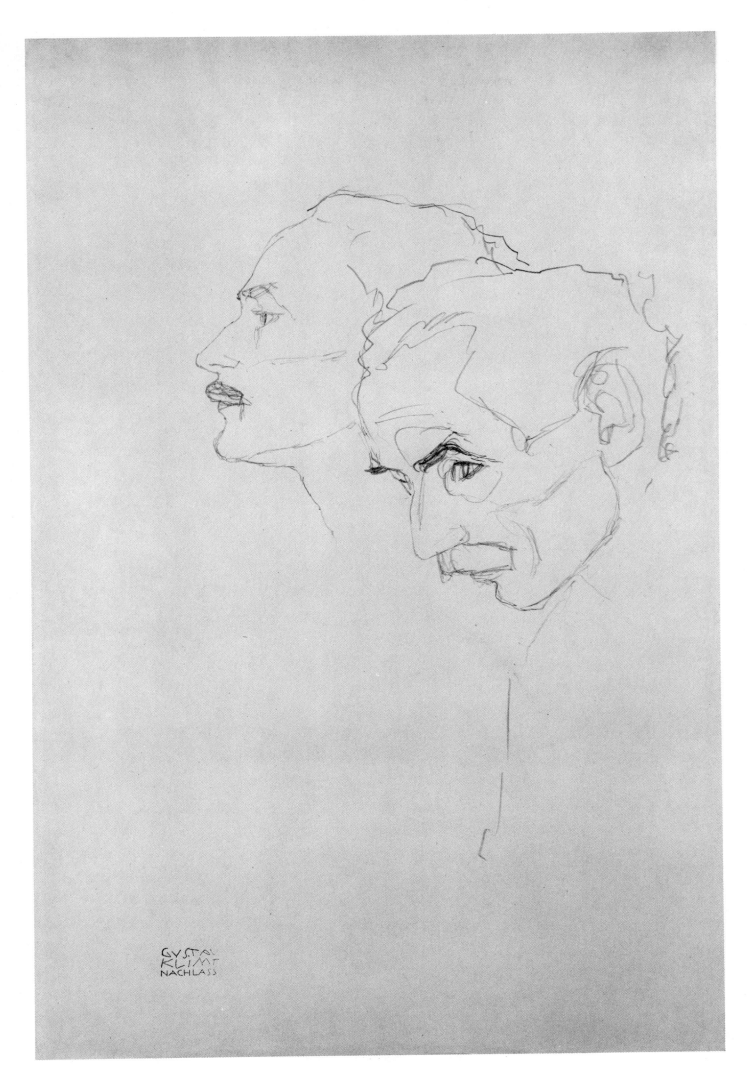

67. Portrait heads of two men; 1912/16.

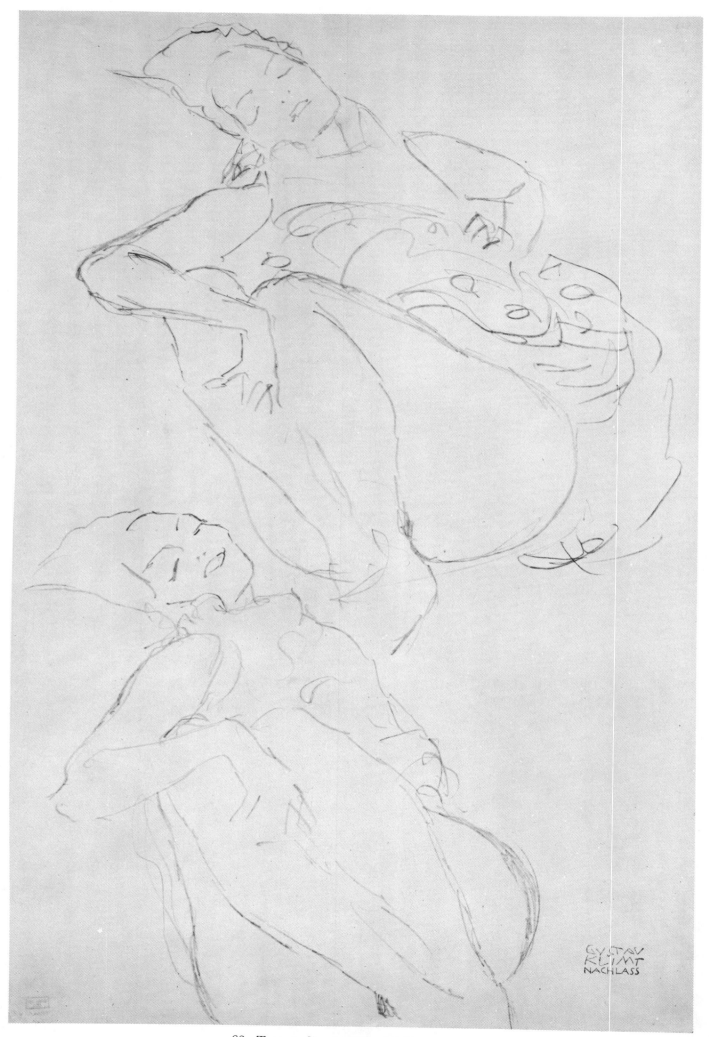

68. Two studies for *The Maiden*; 1913.

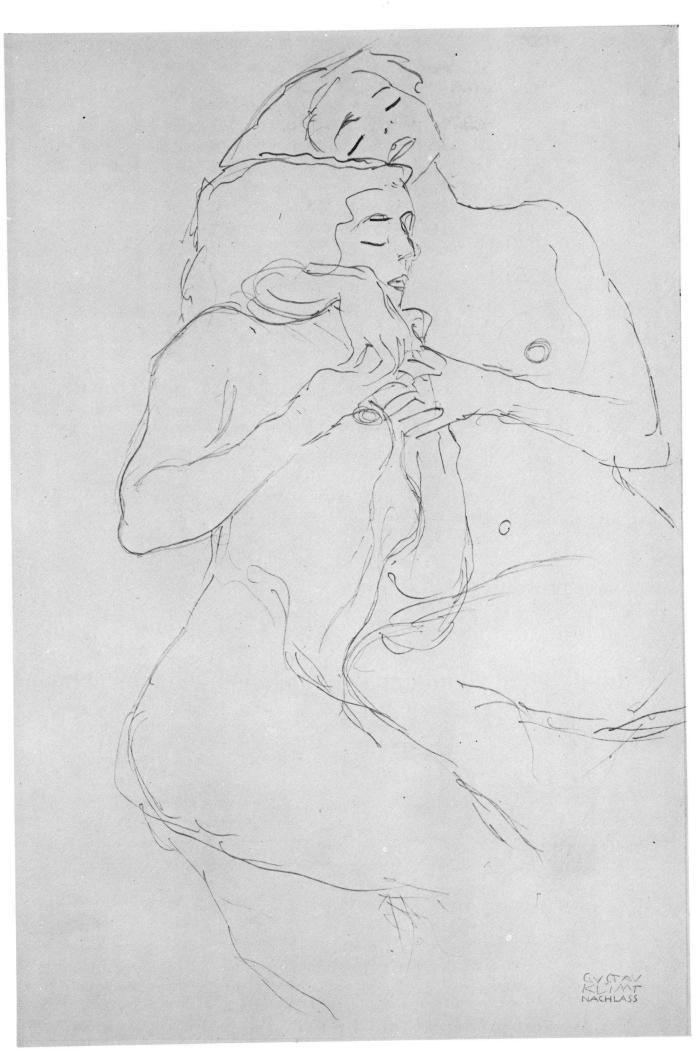

69. Two girls; c. 1913.

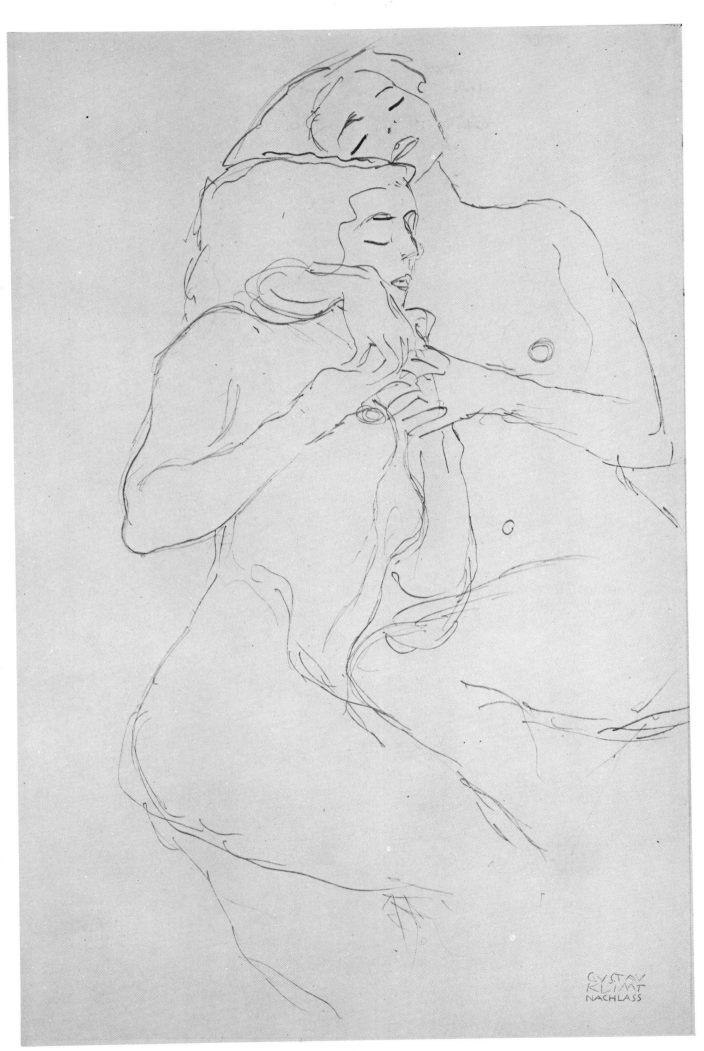

69. Two girls; c. 1913.

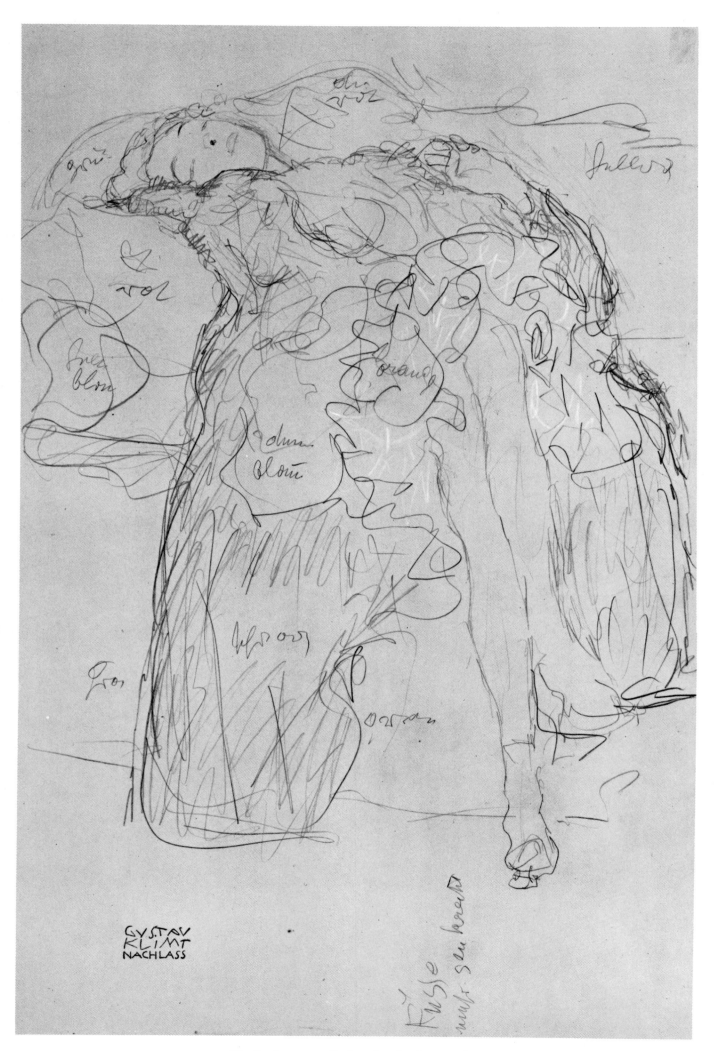

70. Lady on a sofa, leaning back; 1913/15.

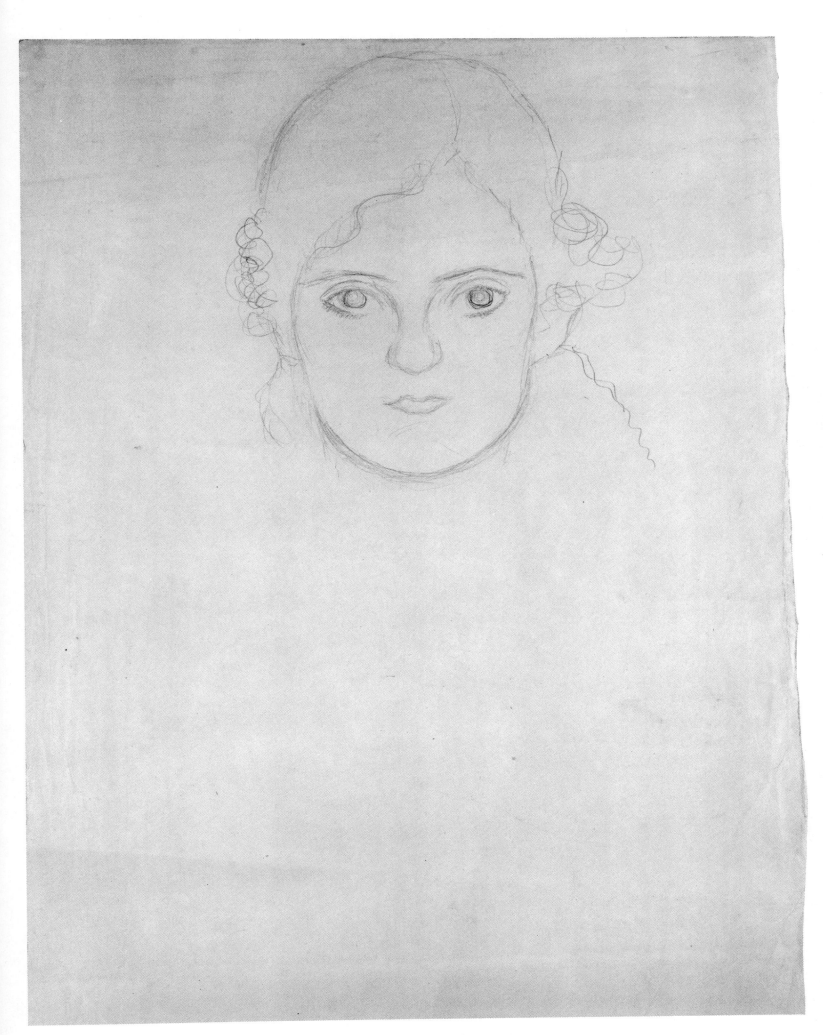

71. Female portrait head; c. 1914.

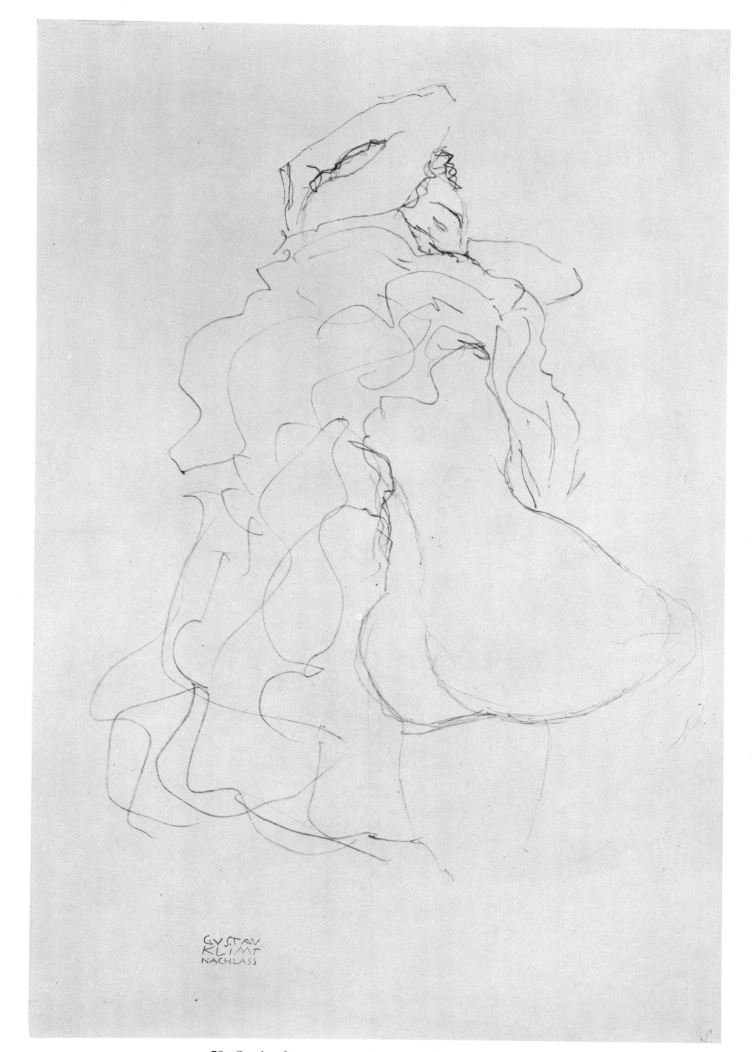

72. Seminude woman moving toward the right; c. 1914.

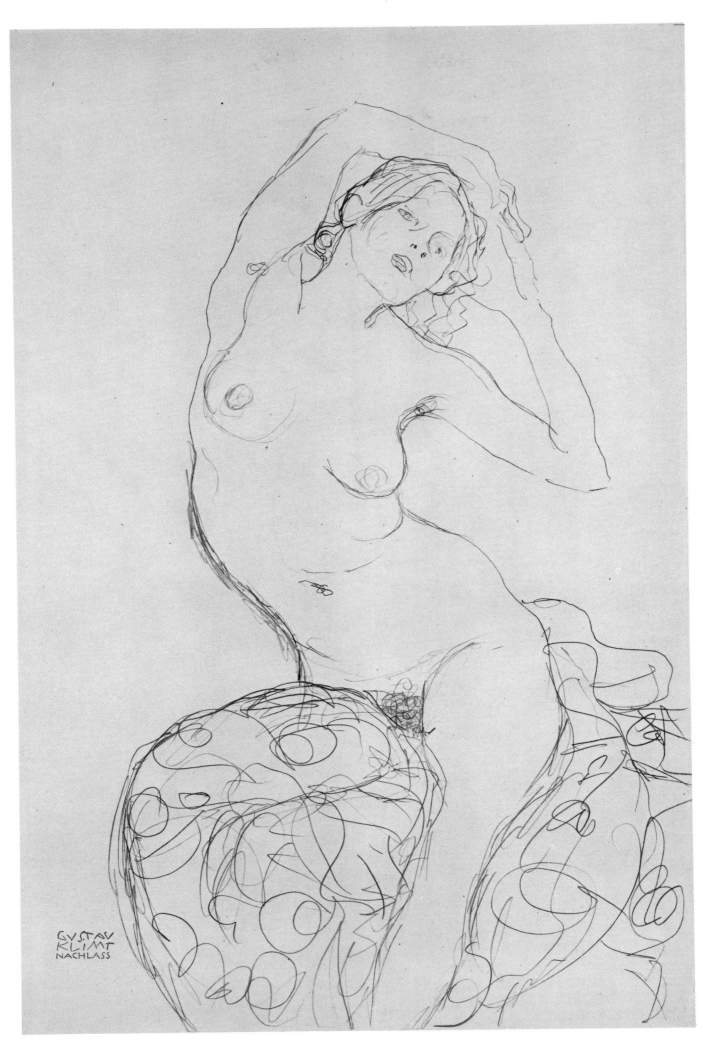

73. Seated nude; 1914/16.

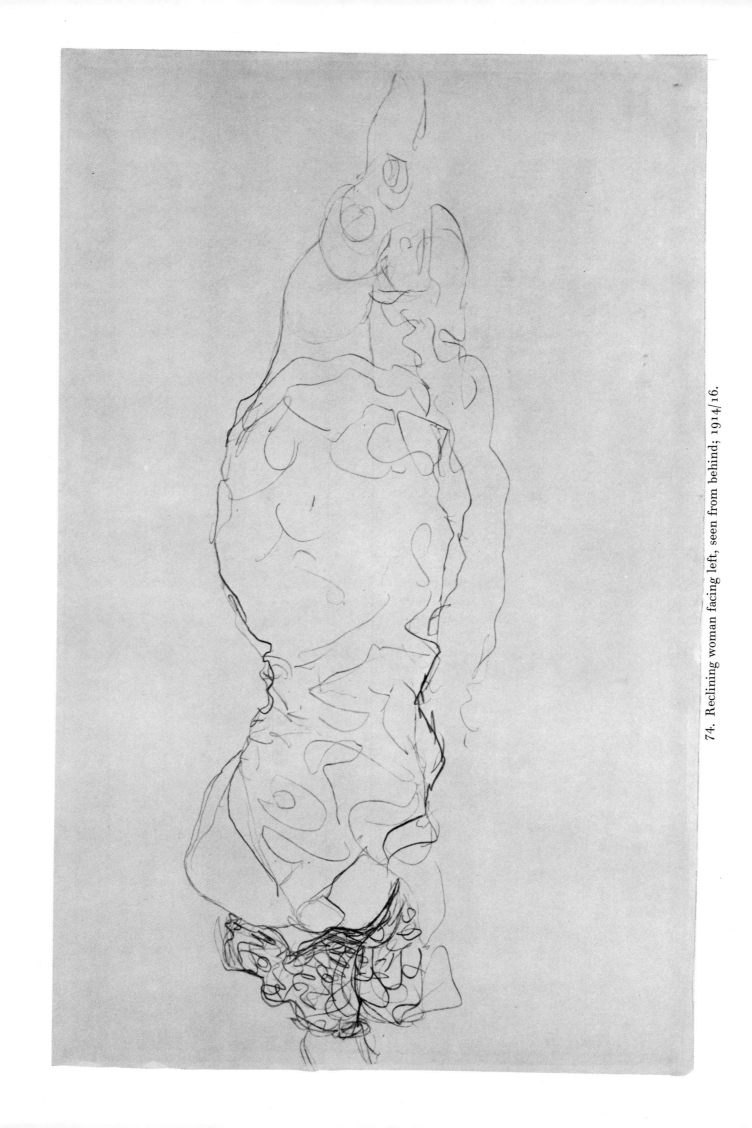

74. Reclining woman facing left, seen from behind; 1914/16.

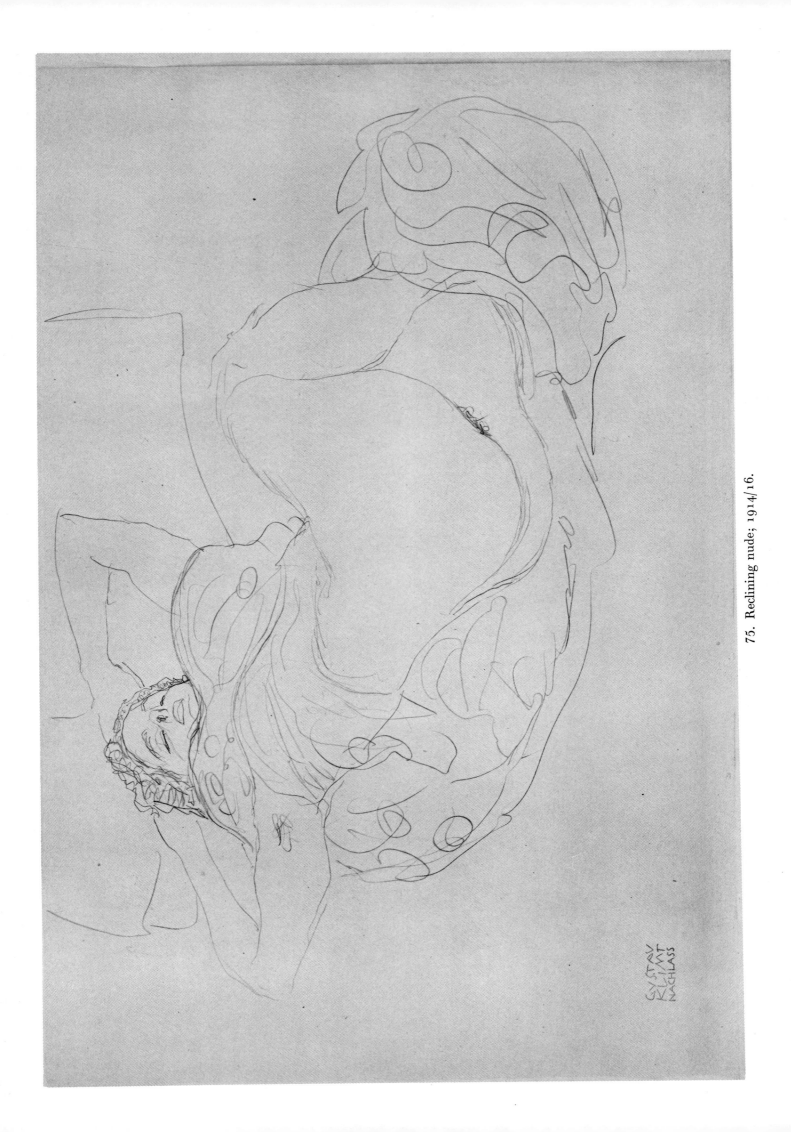

75. Reclining nude; 1914/16.

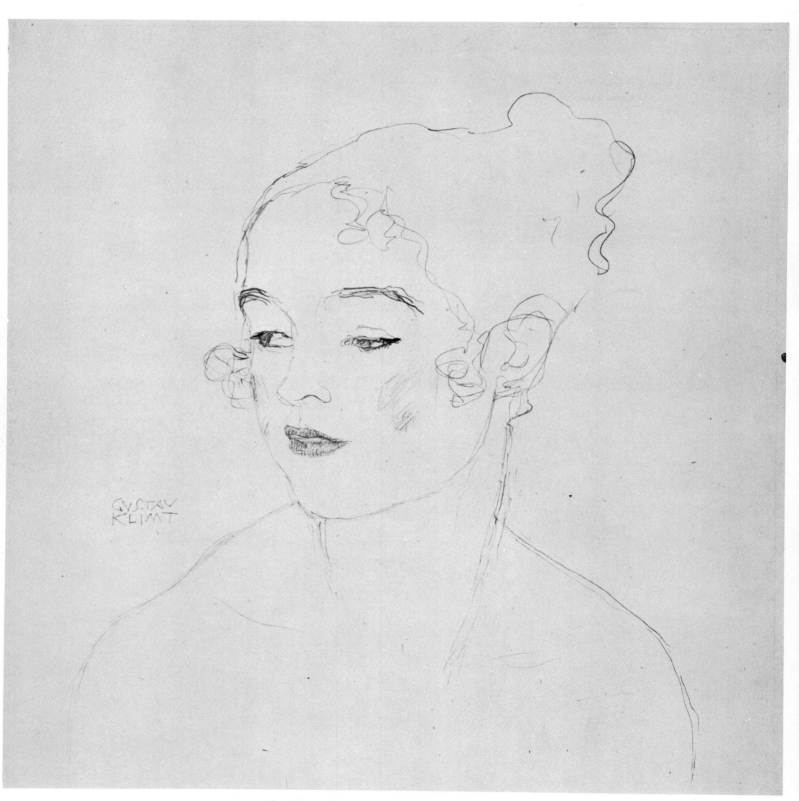

76. Sketch for a portrait of a girl; 1914/17.

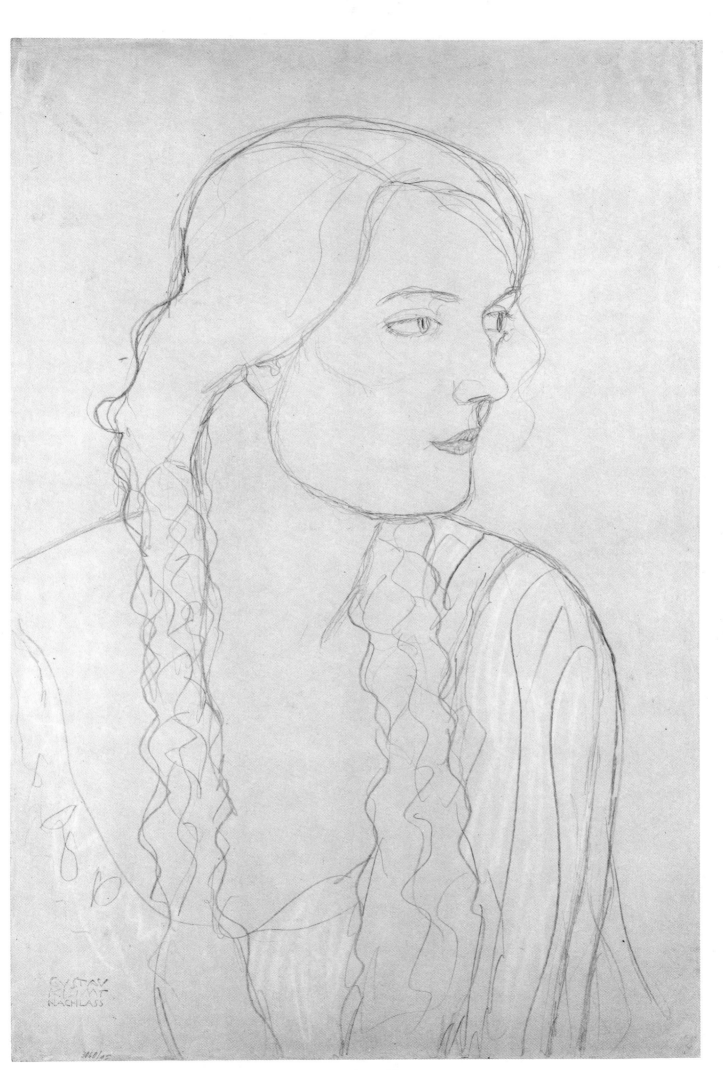

77. Portrait of a girl with braids; c. 1915.

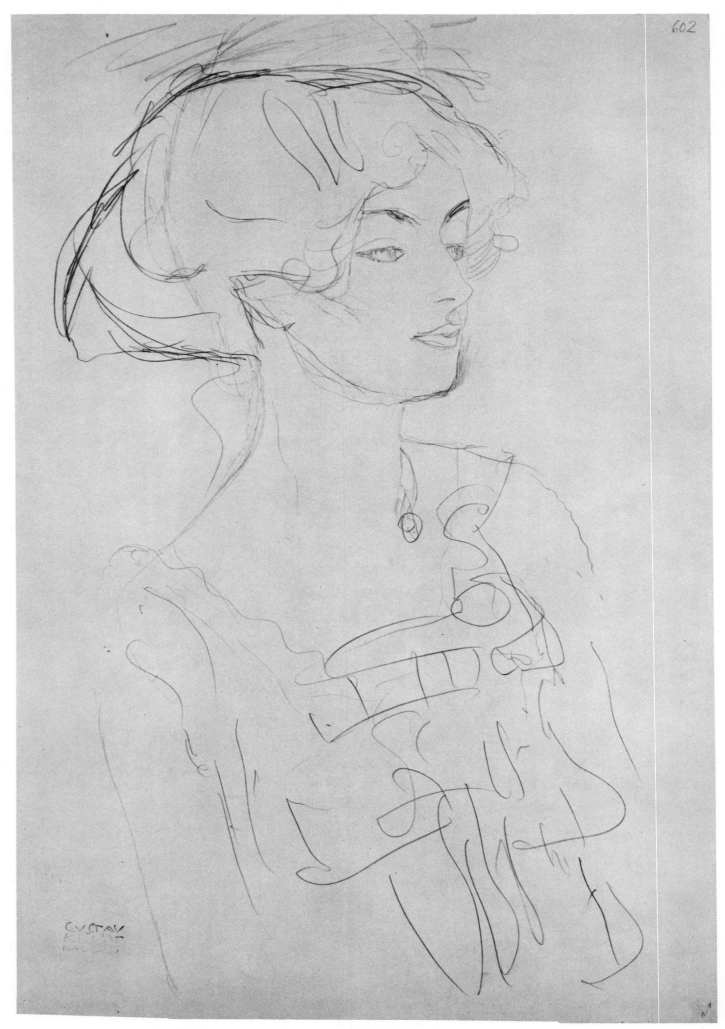

78. Half-length figure of a lady in three-quarter view facing right;
c. 1915.

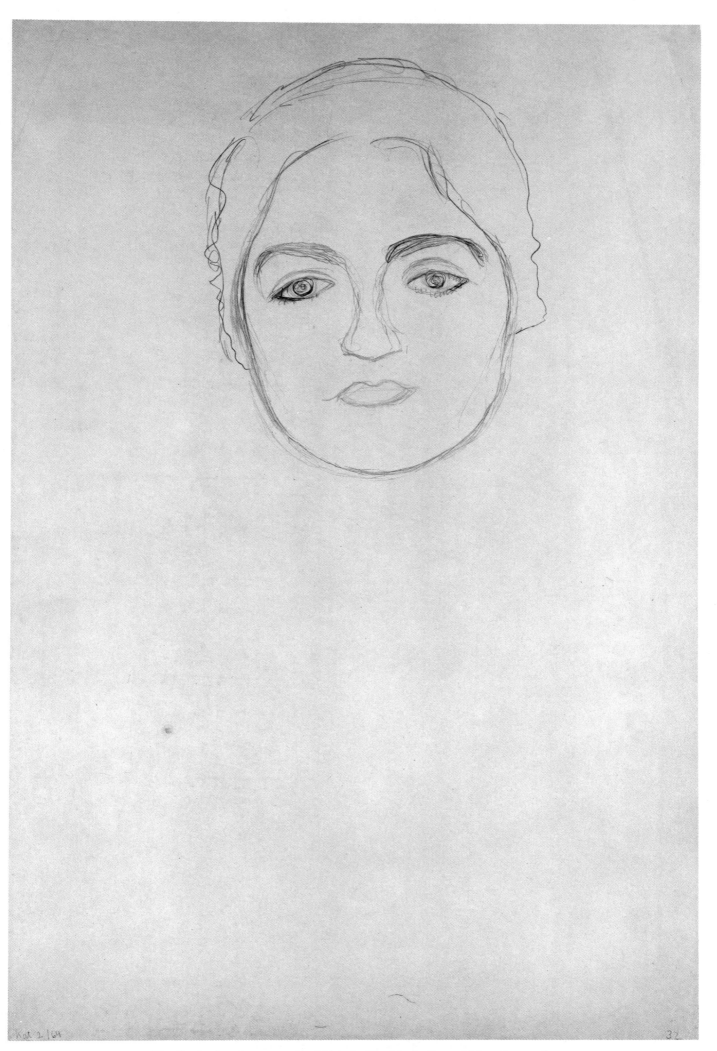

79. Study for the portrait of Friederike Maria Beer (-Monti); 1916.

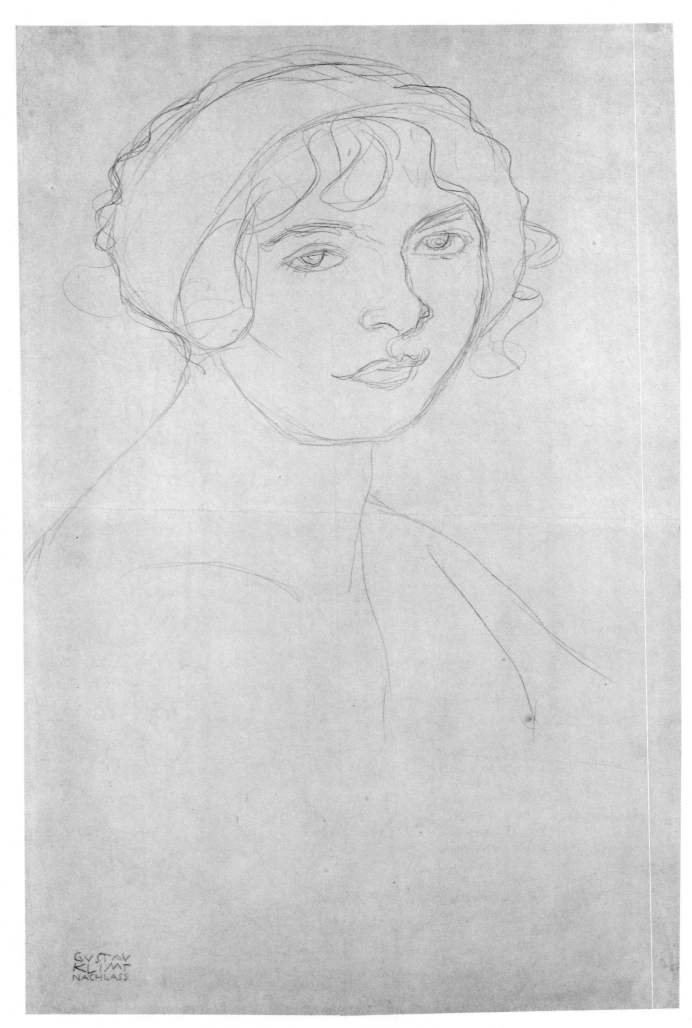

80. Portrait of a woman with short hair; c. 1916.

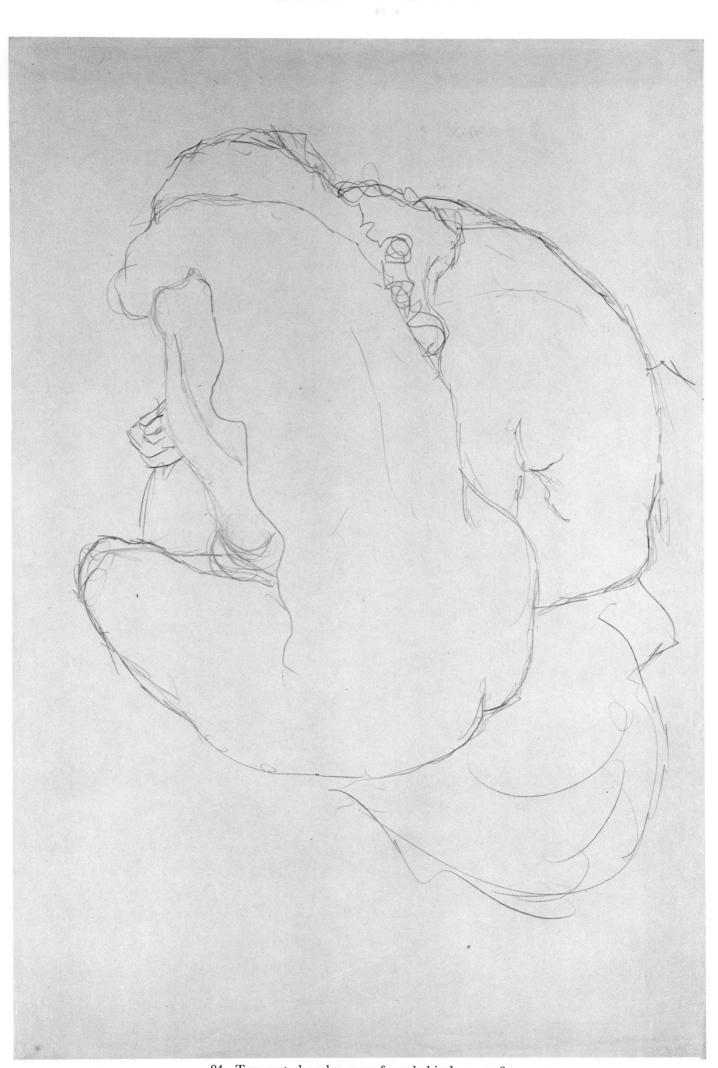

81. Two seated nudes, seen from behind; c. 1916.

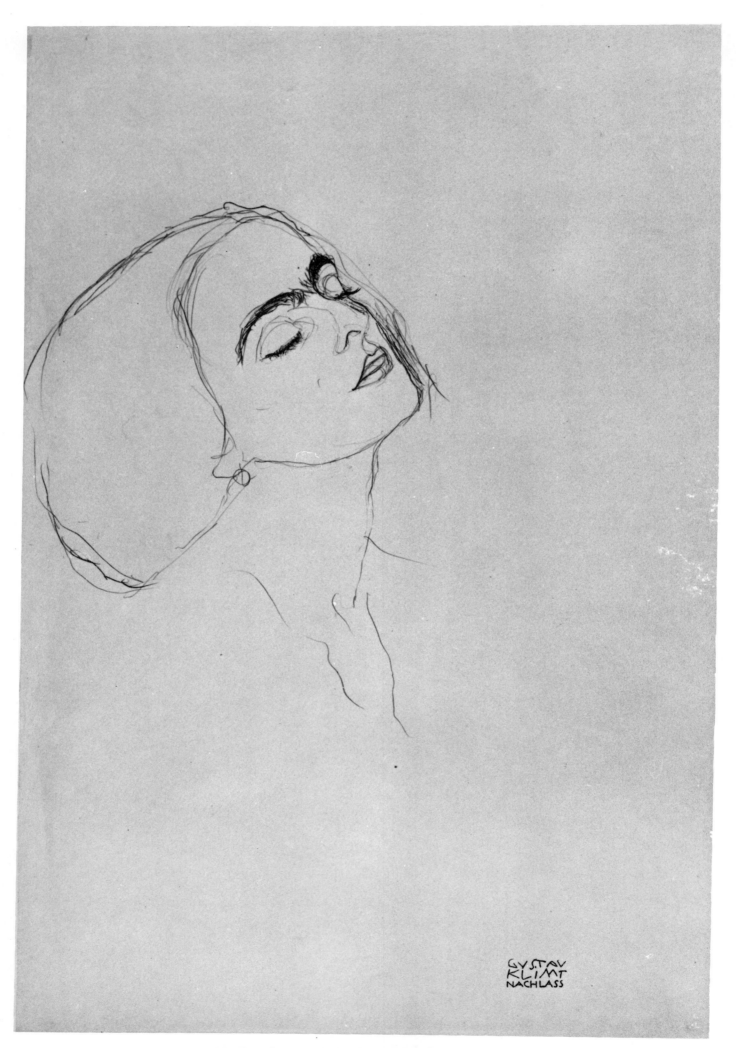

82. Female portrait head with closed eyes; c. 1916.

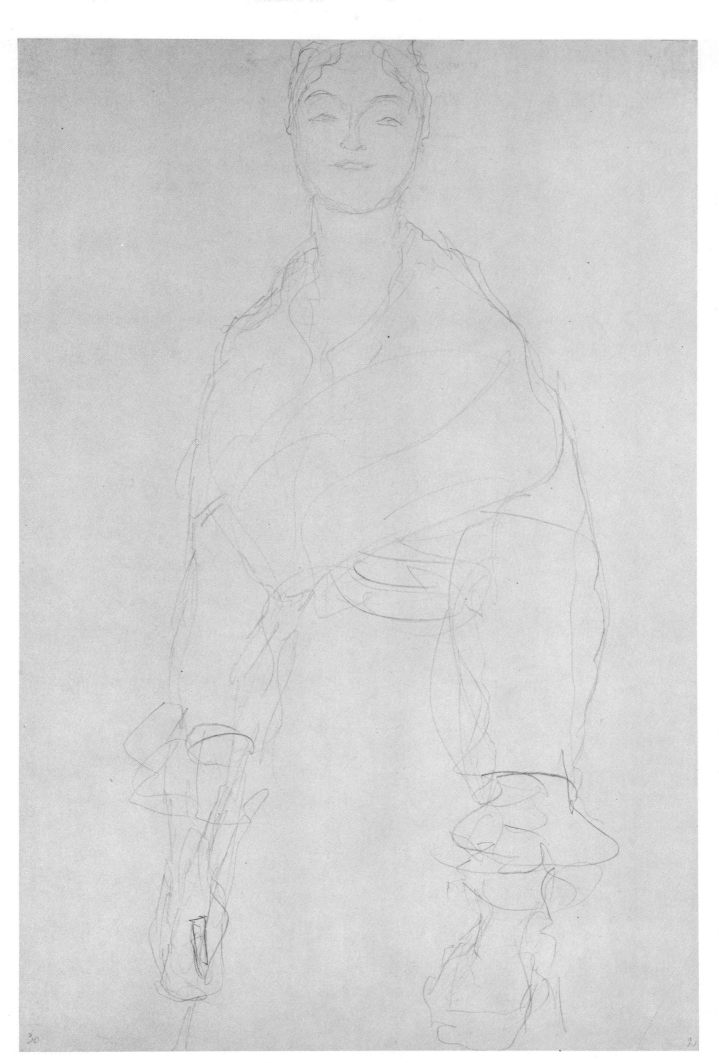

83. Portrait figure of a lady; c. 1916.

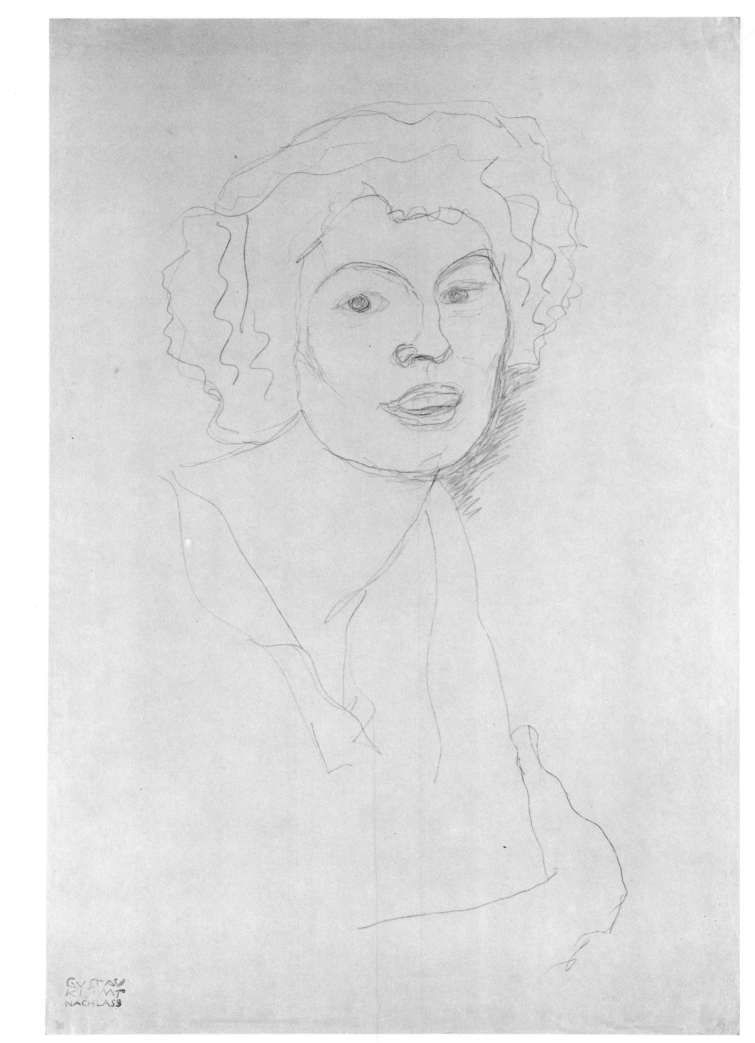

84. Portrait of a lady; c. 1916.

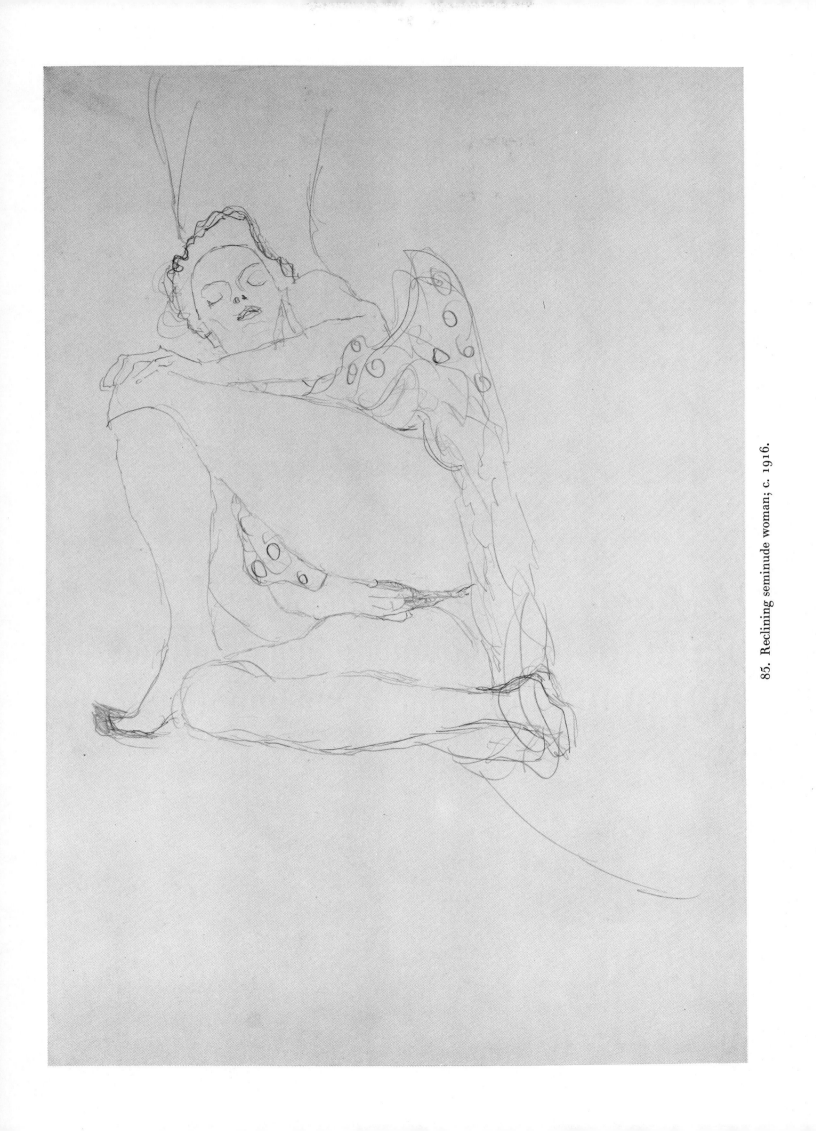

85. Reclining seminude woman; c. 1916.

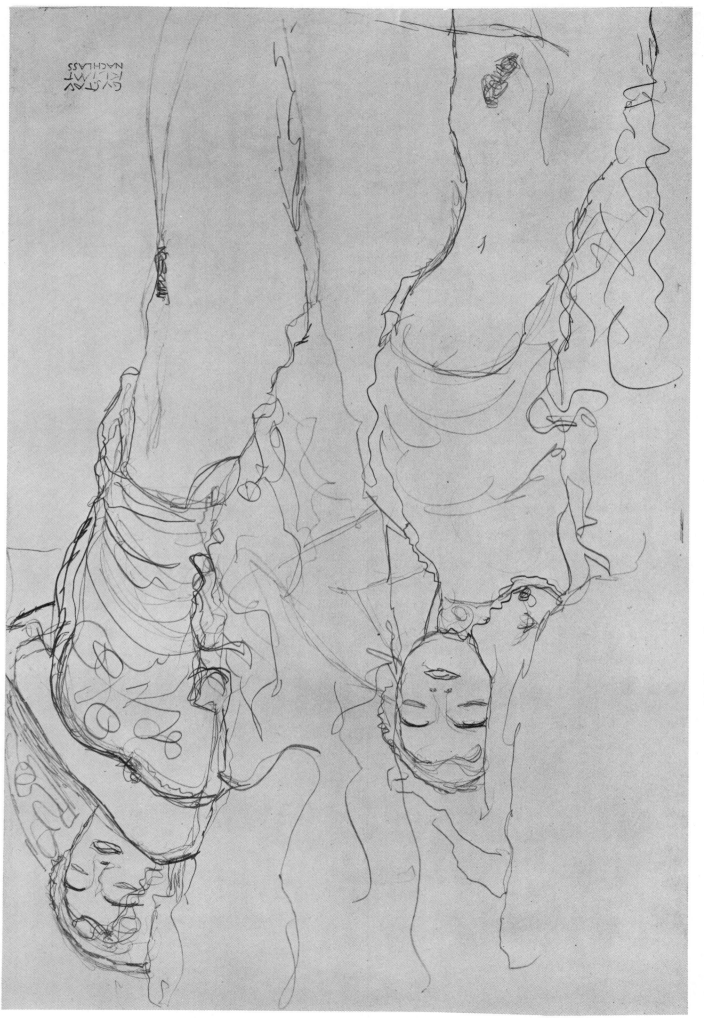

86. Two studies of a reclining seminude woman facing left; 1916/17.

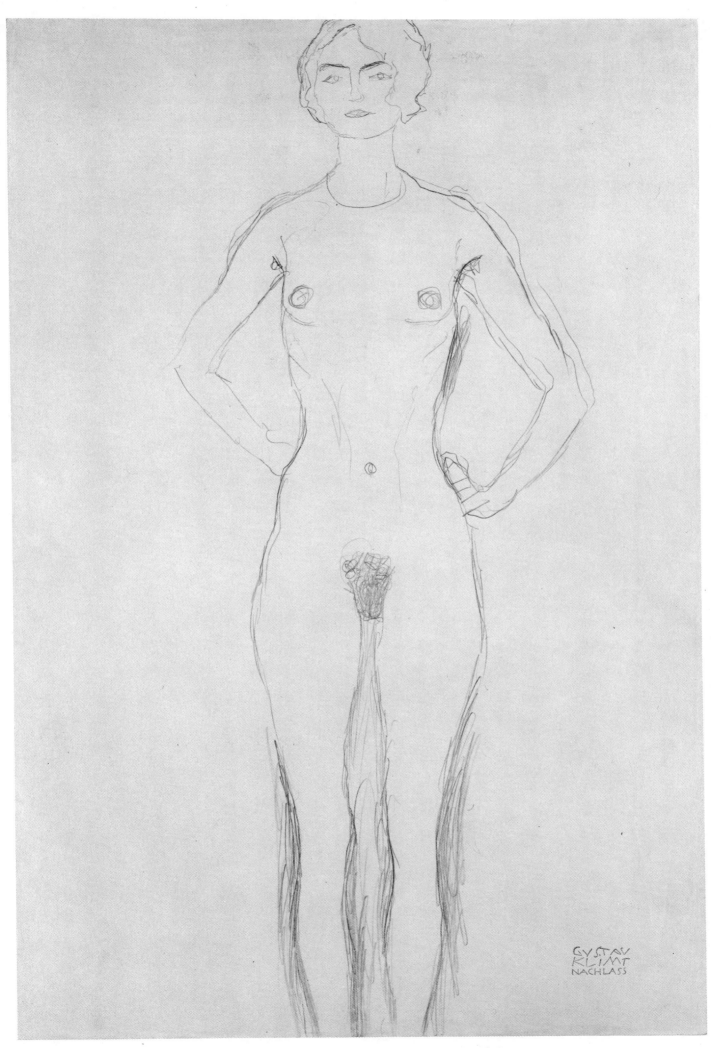

87. Standing nude with hands on hips; 1916/18.

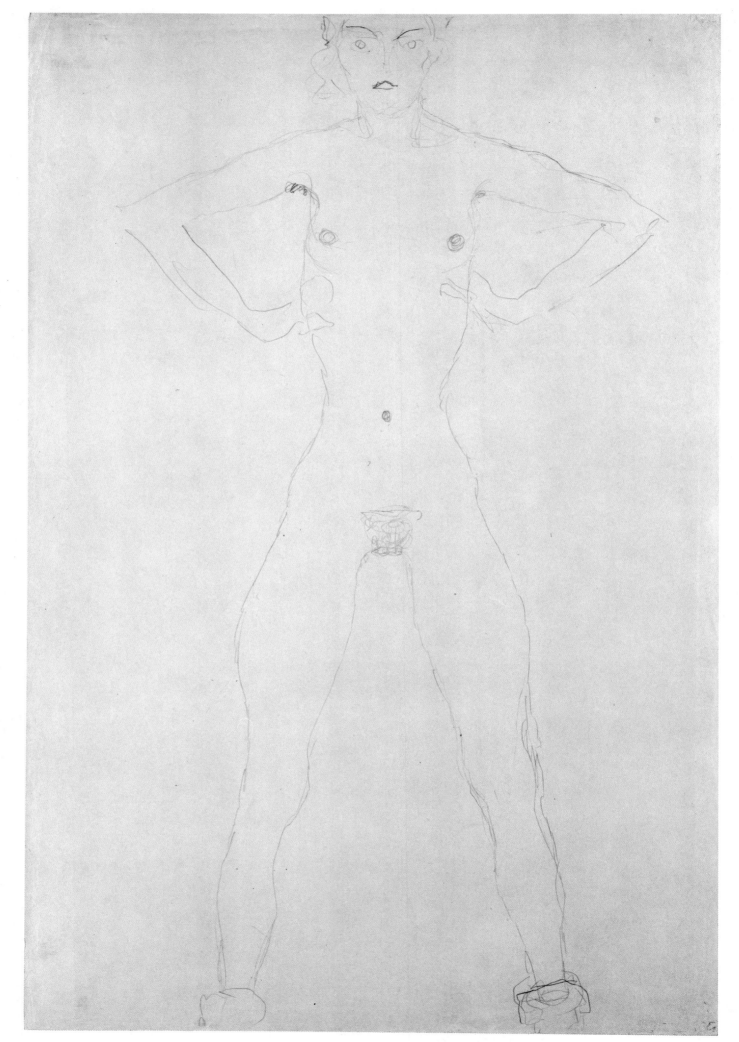

88. Standing nude with bent elbows; 1916/18.

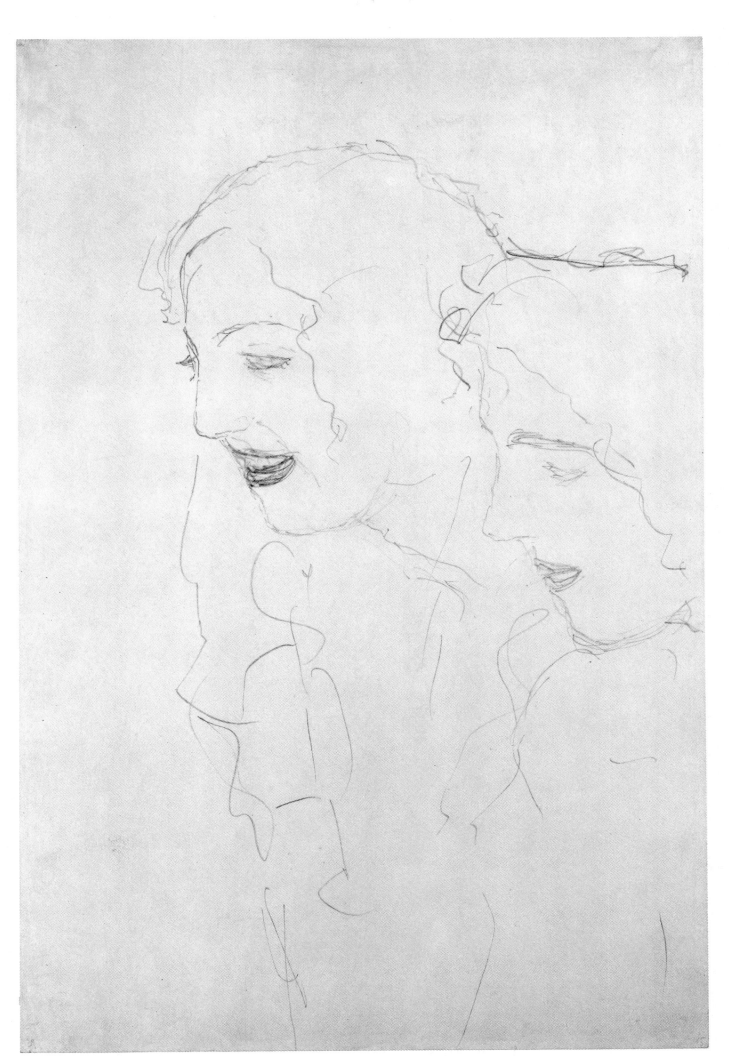

89. Heads of two women; 1916/18.

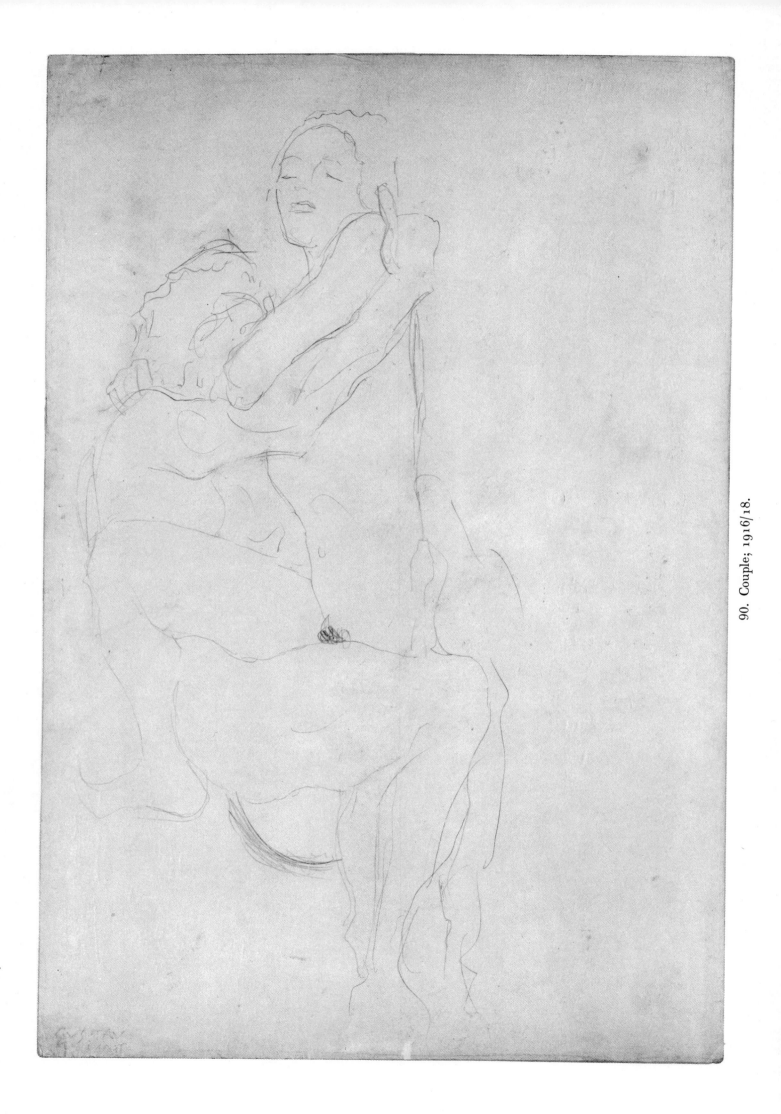

90. Couple; 1916/18.

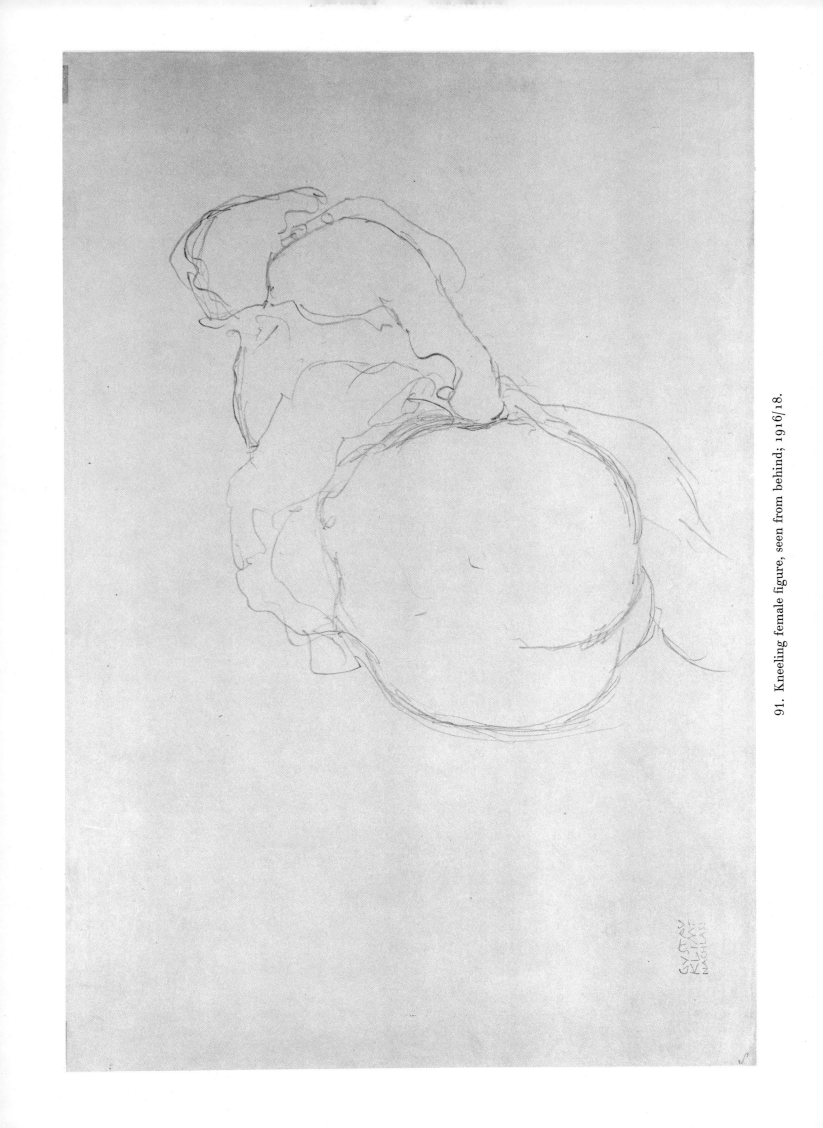

91. Kneeling female figure, seen from behind; 1916/18.

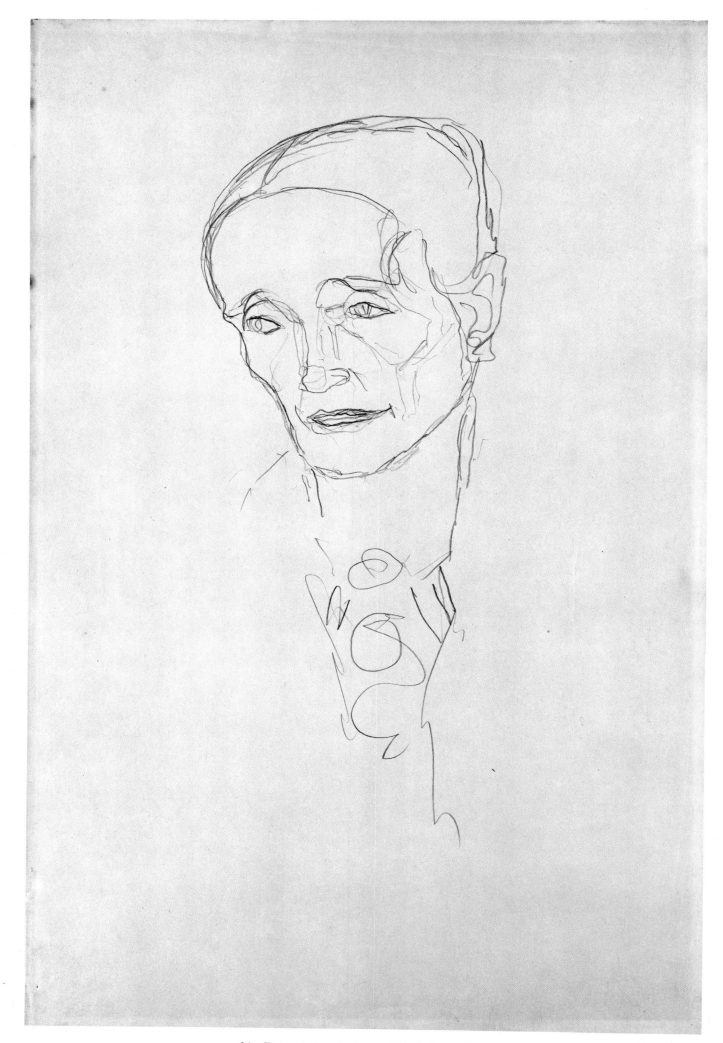

92. Portrait head of an old lady; 1916/18.

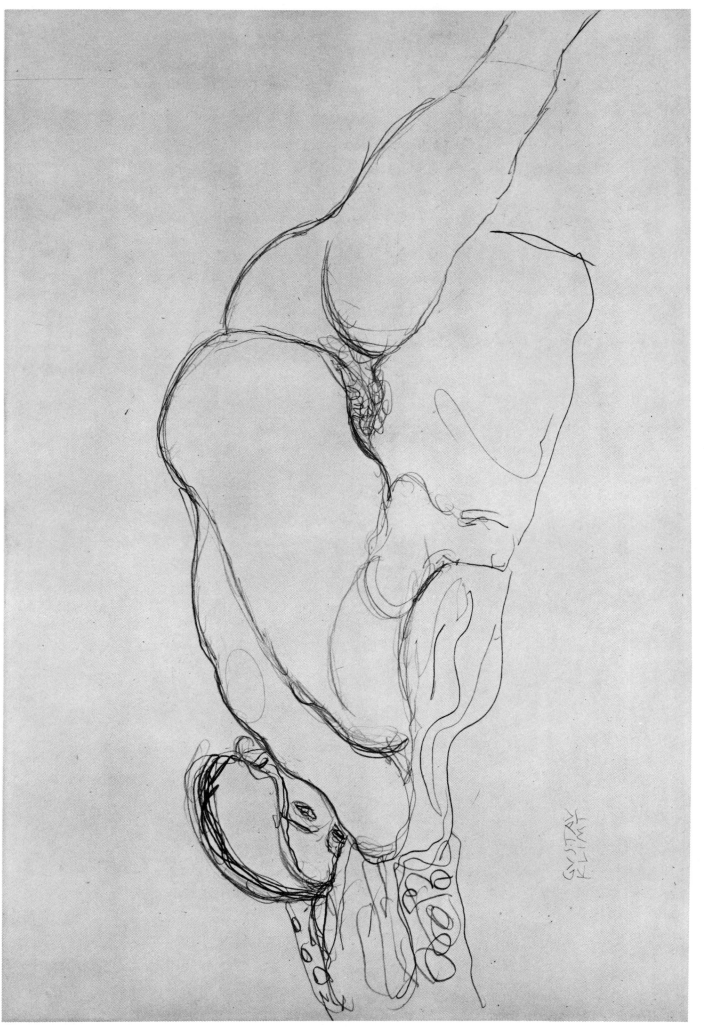

93. Nude lying prone with her left leg drawn up; c. 1917.

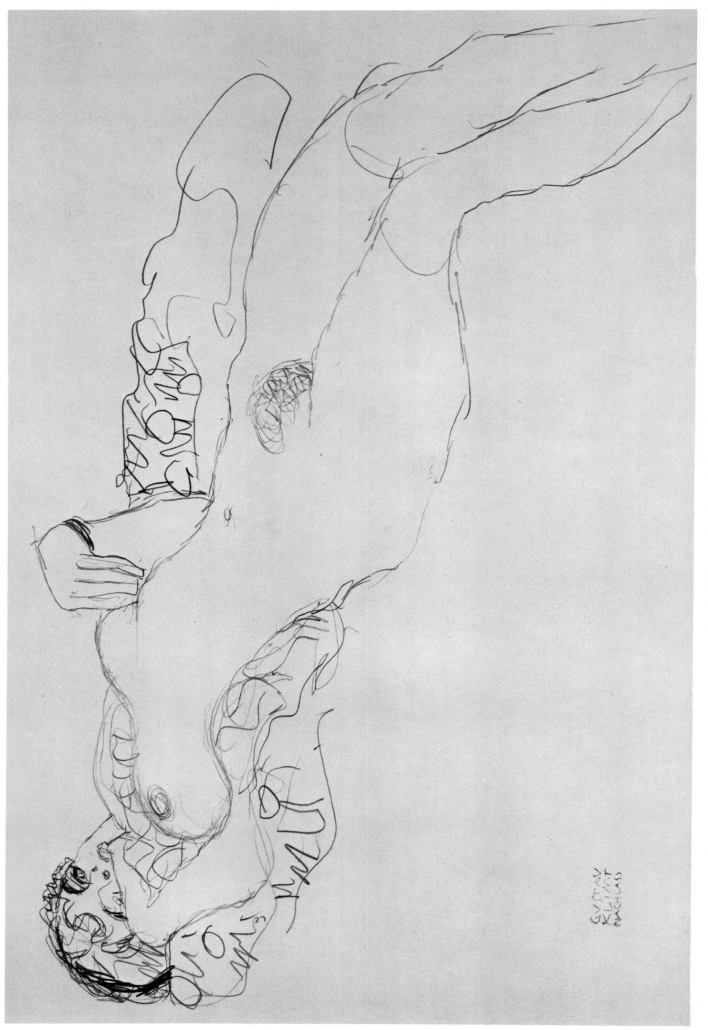

94. Reclining nude facing left; c. 1917.

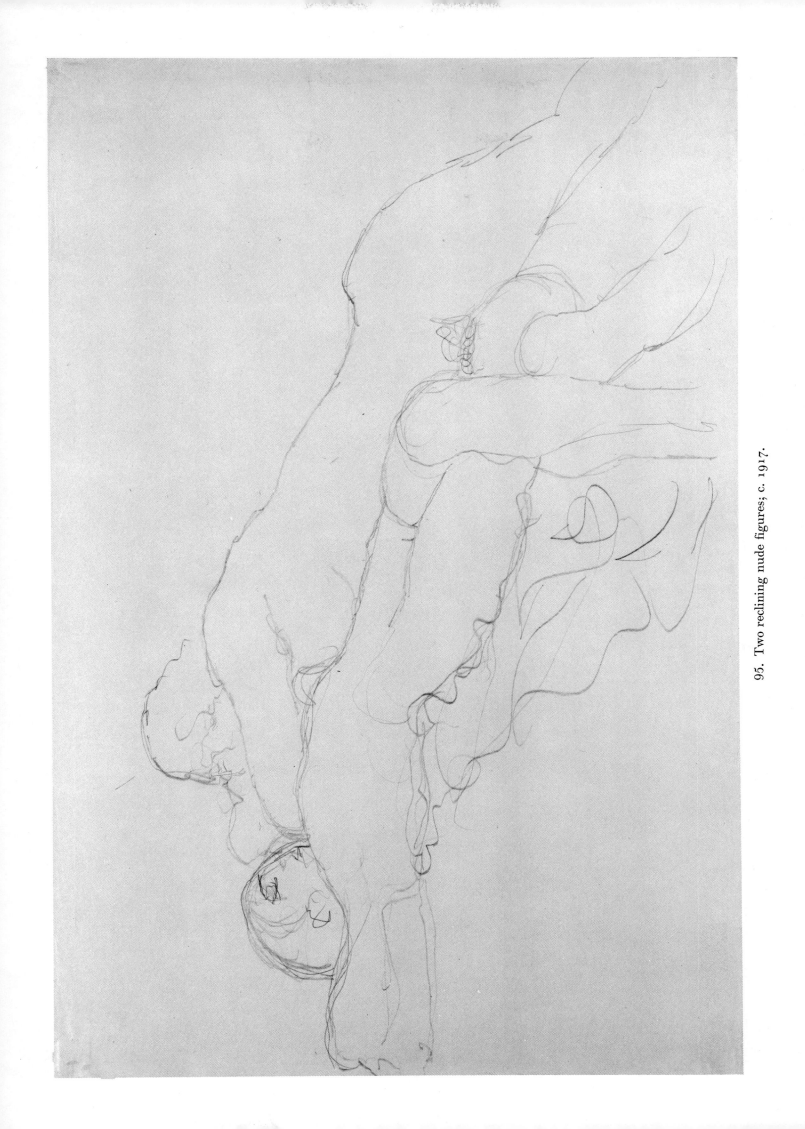

95. Two reclining nude figures; c. 1917.

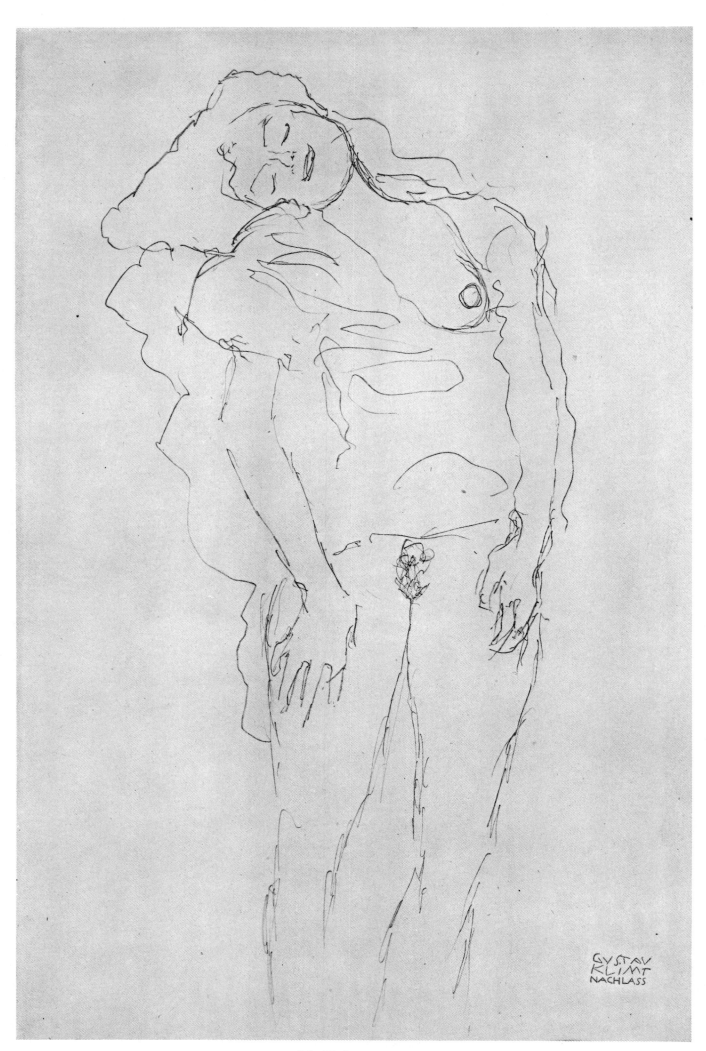

96. Nude; c. 1917.

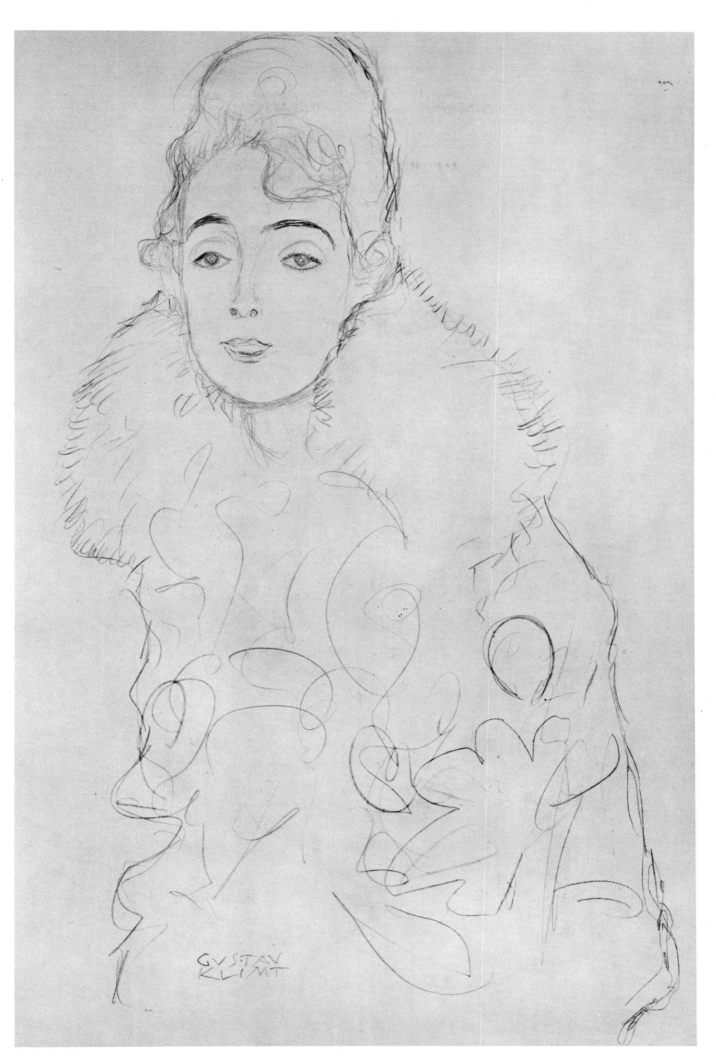

97. Half-length figure of a lady in a fur collar in three-quarter view;
c. 1917.

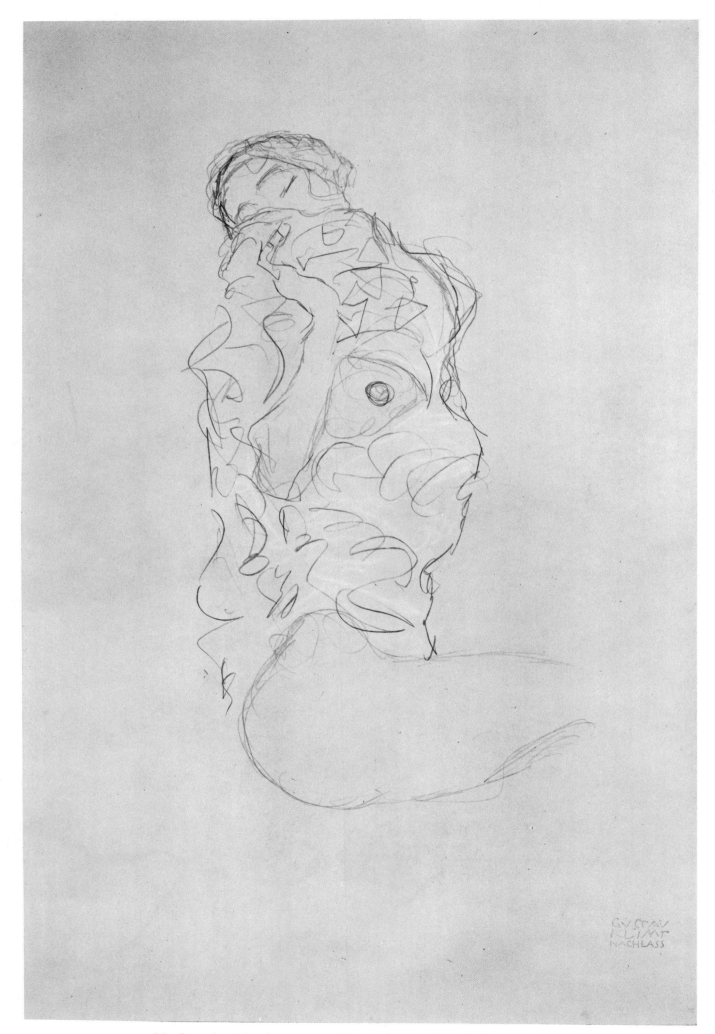

98. Seated seminude woman with trunk turned to the left; 1917/18.

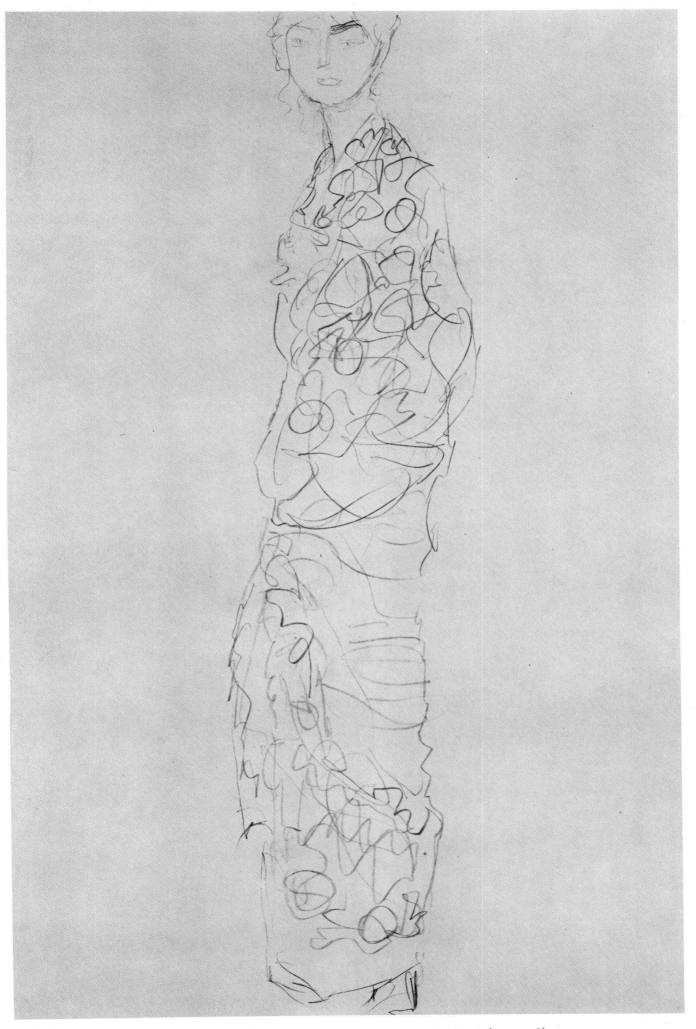

99. Study for the uncompleted portrait of Dora Breisach (1917–18).